IMAGES
of America

WHITE MOUNTAIN NATIONAL FOREST AND GREAT NORTH WOODS

White Mountain National Forest
Ranger Districts

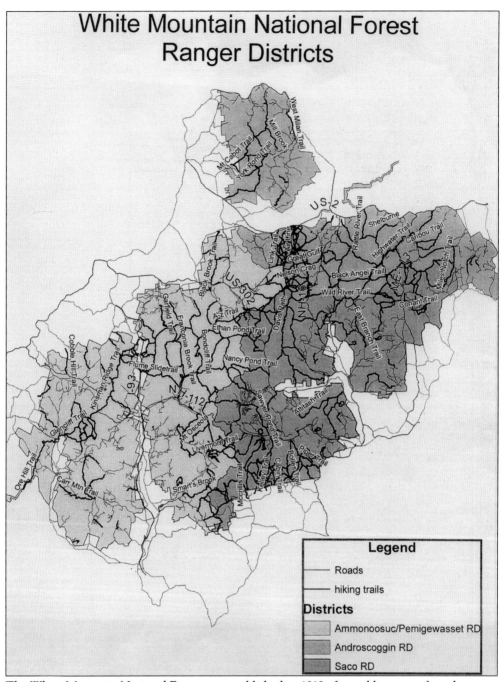

The White Mountain National Forest was established in 1918 after public outcry forced passage of the Weeks Act, which allowed the federal government to purchase private land east of the Mississippi River. (White Mountain National Forest.)

ON THE COVER: This is a perfect location to view Carter Dome (elevation 4,832 feet) from Wildcat Mountain. It is interesting to note that the name Mount Carter is applied only to the peaks nearly behind the Glen House. (White Mountain National Forest.)

IMAGES
of America

WHITE MOUNTAIN NATIONAL FOREST AND GREAT NORTH WOODS

Bruce D. Heald, Ph.D.

ARCADIA
PUBLISHING

Published by Arcadia Publishing
Charleston, South Carolina

Printed in the United States of America

Library of Congress Control Number: 2010936401

For all general information, please contact Arcadia Publishing:
Telephone 843-853-2070
Fax 843-853-0044
E-mail sales@arcadiapublishing.com
For customer service and orders:
Toll-Free 1-888-313-2665

Visit us on the Internet at www.arcadiapublishing.com

This book is respectfully dedicated to all those benefactors, patrons, and friends of the Society for the Protection of New Hampshire's Forest who promoted the passage of the Weeks Bill in 1911.

CONTENTS

ACKNOWLEDGMENTS

Thanks go to Appalachian Mountain Club, John B. Allen, Rebecca Alosa, Balsams Resort and Wilderness, Steve Barba, Boston & Maine Railroad, Cannon Mountain Ski Area, Chisholm's White Mountains, Cranmore Ski Area, Terry Fifield, Sarah Jordan, Loon Mountain Ski Area, New Hampshire American Guide, New Hampshire Fish and Game, Bryant F. Tolles Jr., Wildcat Mountain Ski Area. Special credit is given to the White Mountain National Forest, which supplied the images for this publication.

INTRODUCTION

The White Mountains are sentinels to the Great North Woods and the silent jewels in the wilderness of the Granite State. The White Mountains have been well described as nature's mammoth museum since geologists have traced their formation to the last ice floor, which traversed New England, crossed New Jersey and southern New York, and, thus, created the beautiful White Mountain National Forest.

From the earliest settlement of New Hampshire, the White Mountains have been the state's great natural attraction. The bald summits, white during eight to nine months of the year, were the first lands sighted by homecoming ships in the Atlantic and the last, seen as clouds on the horizon, by ships outward bound. However, the early settlers of the Granite State had little appreciation of the beauties of the Appalachian Mountain Range.

From 1885 to 1910, conservationists crusaded for the preservation of the White Mountains. In 1911, after public outcry forced the passage of the Weeks Act, the White Mountain National Forest Reserve was established, allowing the federal government to purchase private land east of the Mississippi River; the Weeks Act was signed by President Taft on March 1, 1911. In 1918, the White Mountain National Forest was established by a presidential proclamation. Before the establishment of the national forest, the land had been ravaged by uncontrolled logging activities, and fires raged across the landscape.

Today, the White Mountain National Forest covers a total of 784,505 acres (1,225 square miles). It is the only national forest located in either New Hampshire or Maine. Over 100 miles (160 kilometers) of the Appalachian Trail traverses the White Mountain National Forest.

The forest consists of three discontinuous areas. The main region of the national forest included the Presidential Range and several others, including the Franconia, Twin, Bond, Sandwich, Willey, and Carter-Moriah Ranges. Within this region, there exists five designated federal wilderness areas, namely the Presidential Range–Dry River Wilderness, the Great Gulf Wilderness, the Sandwich Range Wilderness, the Caribou-Specked Mountain Wilderness, and the Pemigewasset Wilderness. This book's journey through the forest wilderness will include the Presidential Range–Dry River, the Great Gulf, the Pemigewasset, and the Sandwich Range Wildernesses.

Central in the forest is the Presidential Range, which runs in a double curve from northeast to southwest. Inclusive in the range from the north are Mounts Madison, Adams, Jefferson, and Clay, all of which sweep up Mount Washington's southwest side from the Presidential Range known as the noble Franconia Mountains. Like that grouping of the Presidential Range around Mount Washington, those in the Franconia Mountains look up to the high, bare summit of Mount Lafayette.

The Dry River rises in Oakes Gulf and flows southwest through a wooded mountain valley between the southern part of the Presidential Range to its west and the lower Montalban Ridge, including Mount Isolation, to its east.

Between the Franconia Mountains and those that hem in Crawford Notch on the west are the vast highlands, the Pemigewasset Wilderness, which are more than 4,000 feet high.

Southeast of these rugged peaks is the Sandwich Range, which forms a majestic mountain barrier. The pyramidal cone of Mount Chocorua rises conspicuously in the east, flanked by Passaconaway Mountain, sacred Whiteface, Paugus, and the Sandwich Dome.

Because of the natural beauty of the wilderness areas, its 1,200 miles of hiking trails, 23 campgrounds, and large number of ski areas within or near its boundaries, the White Mountain National Forest is one of the most visited natural sites in the country. Thousands upon thousands of tourists from all over the world make seasonal visits to this recreational haven each year to rejuvenate the spirit. Land management of these areas focuses on timber harvesting, livestock grazing, water, wildlife, and recreation. Unlike many federal lands, commercial use of the national forest is permitted and, in many cases, encouraged.

The White Mountain National Forest and Great North Woods is dedicated to preserving and maintaining the significant heritage resources and to sharing the values of these resources with the public.

Return with me to the cloud-haunted north woods (the land up above), the evergreen wilderness of the White Mountains and forest pines. This journey of rare images will take us through the memories of days past, for here we listen to the murmuring mountain streams that have fallen to the meadows and finally to the sea; to the music among the trees swayed by the winds, which rise and fall with the unforgettable past; and to the rustling of leaves that flutter to the ground during the autumn season. The hills are alive in New Hampshire.

Respectfully, we celebrate the 100th anniversary of the passage of the Weeks Act of 1911 being the establishment of the White Mountain National Forest Reserve.

—Bruce D. Heald, Ph.D.
Plymouth State University

WHITE MOUNTAIN'S 4,000-FOOTERS

The following make up the current list of White Mountain's 4,000-footers, along with their respective elevations (in feet), in alphabetical order:

Adams (5,774), Bond (4,698), Bondcliff "The Cliffs" (4,265), Cabot (4,170), Cannon (4,100), Carrigain (4,700), Carter Dome (4,832), East Osceola (4,156), Eisenhower (4,780), Field (4,340), Flume (4,328), Galehead (4024), Garfield (4,500), Hale, (4,054), Hancock (4,420), Isolation (4,004), Jackson (4,052), Jefferson (5,712), Lafayette (5,260), Liberty (4,459), Lincoln (5,089), Madison (5,367), Middle Carter (4,610), Middle Tripyramid (4,140), Moosilauke (4,802), Monroe (5,384), Moriah (4,049), North Tripyramid (4,180), North Kinsman (4,293), North Twin (4,761), Osceola (4,340), Owl's Head (4,025), Passaconaway (4,043), Pierce (4,310), South Carter (4,430), South Hancock "South Peak" (4,319), South Kinsman "South Peak" (4358), South Twin (4,902), Tecumseh (4,003), Tom (4,051), Washington (6,288), Waumbek (4,006), West Bond (4,540), Whiteface (4,020), Wildcat (4,422), Wildcat D "Wildcat Ridge" (4,070), Willey (4,285), and Zealand "Zealand Ridge" (4,260).

Note: The term "4,000-footers" refers to the White Mountain 4,000-Footer List established by the Appalachian Mount Club (AMC).

One

THE PRESIDENTIAL RANGE

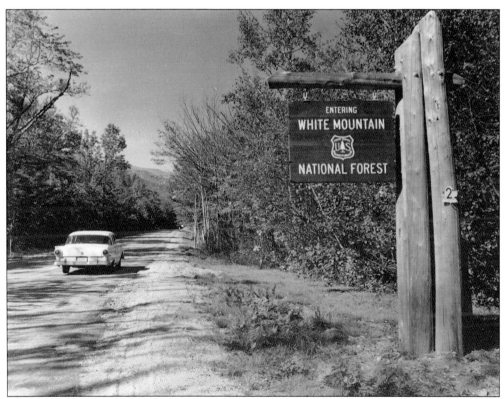

The White Mountain National Forest is the only national forest located in either New Hampshire or Maine. Most of the major peaks over 4,000 feet high in New Hampshire are located here. Over 100 miles of the Appalachian Trail traverses the White Mountain National Forest. The total area of land is 784,505 acres (1,225 square miles).

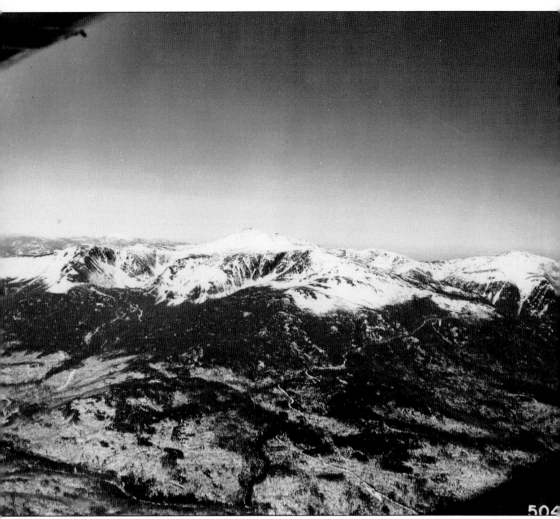

504

The Presidential Range poses majestically in the heart of the White Mountains. This aerial view of the east side of the range shows the carriage road as it weaves up the side of the mountain. Dropping gradually down from that superb height are Mount Monroe (elevation 5,372 feet), Franklin (elevation 5,001 feet), Eisenhower (elevation 4,760 feet), Jackson (elevation 4,052 feet), Pierce (elevation 4,310 feet), and Webster (elevation 3,910 feet). The Dry River rises in Oakes Gulf, a glacial cirque on the south slope of Mount Washington. The river flows southwest through a wooded mountain valley between the southern part of the Presidential to its west and the lower Montalban Ridge. The Presidential Wilderness is comprised of 29,000 acres, which was designated by the 1975 Eastern Wilderness Act in 1984; it was expanded by the New Hampshire Wilderness Act.

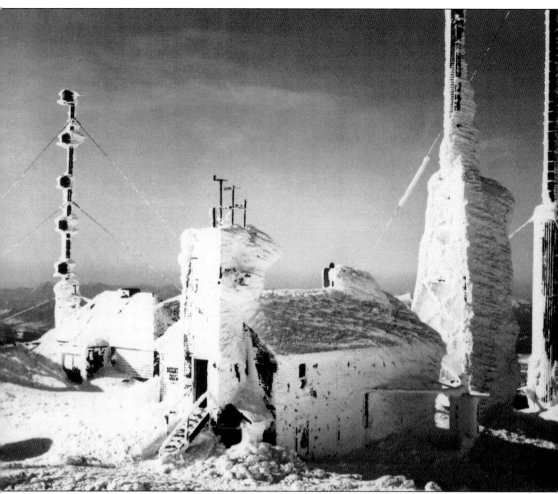

This is a view of the weather installation atop Mount Washington. The present observatory was launched in 1932 with a grant from the New Hampshire Academy of Science. It was that year when the first scientists from around the world gathered their meteorological observations to help develop new theories about the weather. Today, the Mount Washington Observatory is considered a class-A weather station for the US Weather Bureau. This is a winter scene of the Mount Washington summit and the weather station installation for 1937–1938. The observatory is operated by a nonprofit corporation and maintains museum exhibits in the Sherman Adams summit building.

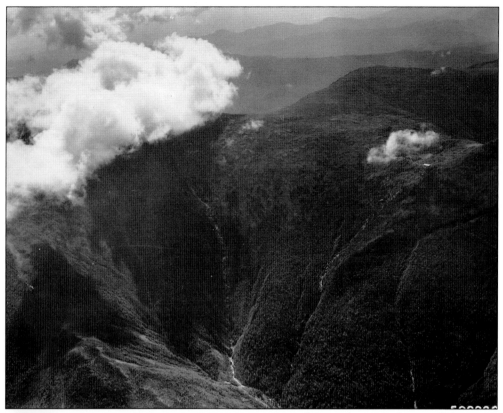

An aerial view is shown of Mount Washington (elevation 6,288 feet), the Lake of the Clouds, and the AMC Hut on Mount Washington as they recline in a cloud cap at the left. Mount Washington is a broad and massive mountain with great ravines, which are cut deeply into its steep profile, leaving buttress ridges that reach up through the timberline and support the upper plateau. The timberline is realized at an elevation of 4,500 to 5,000 feet, depending on the degree of exposure to the weather.

The Upper Ammonoosuc Falls is a striking example of the fury of the little stream as it rushes from its source in the Lake of the Clouds on the side of Mount Monroe. Here at the falls, it rushes and plunges over and under the ledges of glistening granite.

The Lower Falls of the Ammonoosuc River is located between Twin Mountains (elevation 4,761 feet) and Fabyan, along highway 302. The stream descends over rapids and falls for approximately 50 feet and then continues through a narrow gorge of polished ledges of granite. This has been called the wildest stream in all New England, and it may well be for its water drop.

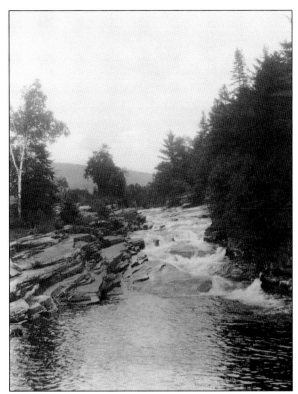

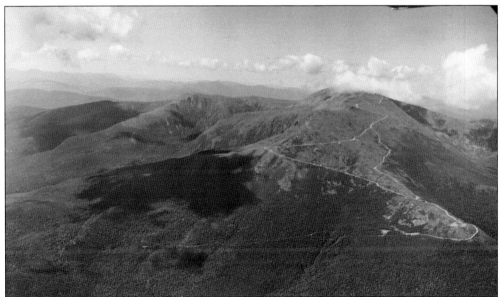

Looking southwest, this is an aerial view of the Mount Washington Auto Road as it winds itself to the summit. It was built between 1855 and 1861. Mount Washington is seen capped in clouds at right. The Mount Washington Auto Road has watched all the events that have shaped the national forest. The 100th anniversary of the Weeks Act is being celebrated in 2011. From the center of the photograph to the left is Huntington Ravine, Tuckerman Ravine, and the Great Gulf of Slides carved out of the eastern slopes of Mount Washington and the Presidential Range.

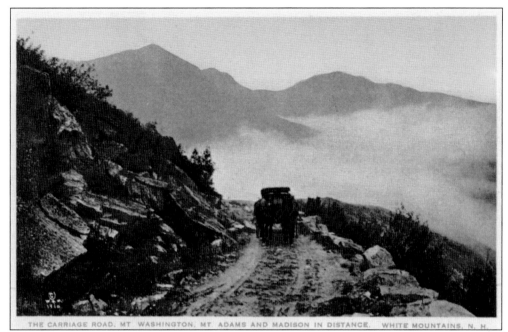

THE CARRIAGE ROAD, MT. WASHINGTON, MT. ADAMS AND MADISON IN DISTANCE. WHITE MOUNTAINS, N. H.

During the early 1900s, a horse-drawn carriage is proceeding up the road to the summit of Mount Washington. Mounts Adams (elevation 5774 feet) and Madison (elevation 5,366 feet) are seen in the distance. For the first few miles, the road climbs through thick scenic woods. The halfway point is almost exactly at the timberline, as seen in the photograph.

Near the summit of Mount Washington, an unidentified tourist is seen enjoying the view of the surrounding ranges. The first ascent of Mount Washington was made by Darby Fields, a New Hampshire settler who accomplished this feat in 1642 from a southerly approach of the mountain. Partly guided by Abenaki Indians and with only primitive equipment at his disposal, he is, thus, alleged to be the originator of all Mount Washington ascensions.

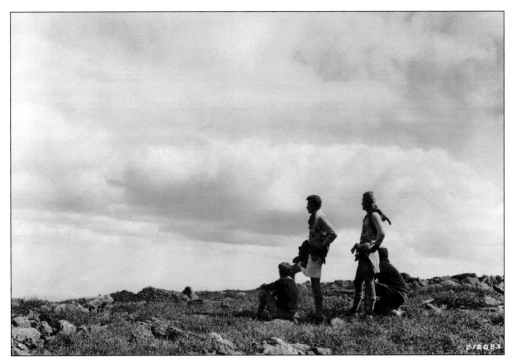

Many early hikers on Mount Washington found that loose, light clothing enabled them to climb more easily. There are well-marked trails, which offer many one-day tramps in the White Mountain National Forest. The Great Gulf Link Trail was formerly a segment of the Great Gulf Trail. It leaves Dolly Copp Campground at the south end of the main camp road, as seen here.

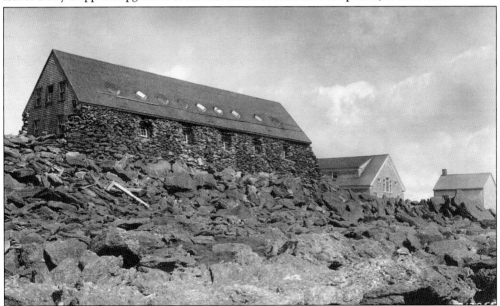

In 1915, the Summit House was erected on Mount Washington. Its construction, as seen in this 1920s photograph, is regarded as the most solid of the buildings that appear on the summit. Its foundation was set deep in concrete, bolted, and strapped with iron, ensuring a safeguard against winds that sometimes reach a velocity of 200 miles an hour.

This is the Crystal Cascade as seen from the Tuckerman Ravine Trail during the winter of 1935. The cascade is easily reached from the Pinkham Notch Visitors' Center by a walk of .4 miles on the trail. During the spring and summer months, the beautiful Alpine Garden lies at the foot of the summit in her full majesty of color near the ravine.

Hikers are enjoying their climb at the junction of the Westside Trail and the Davis Path up Mount Washington. The trail was partly constructed by pioneer trail maker J. Rayner Edmands. The trail is located above the timberline and is very exposed to the prevailing west and northwest winds.

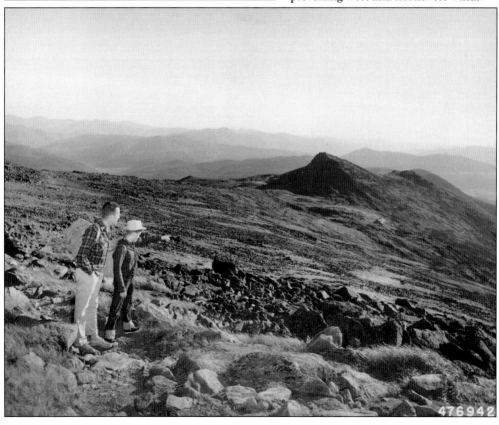

Father and son are studying the marker at the junction of the Westside Trail and the Davis Path on Mount Washington. The sign reads, "AMC (Appalachian Mountain Club), Davis Path, Alpine Garden Tuckerman Ravine, Boott Spur Notchland, Westside Trail–Mount Washington."

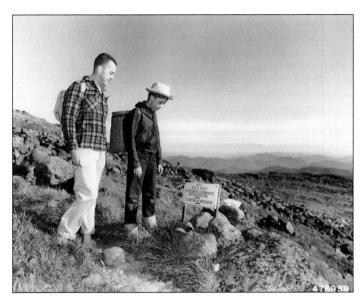

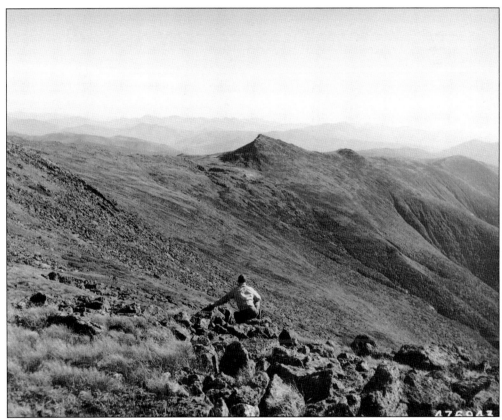

From the Westside Trail up Mount Washington, a lone hiker is enjoying the panorama of the White Mountains, with Mount Monroe, the Lake of the Clouds, and the Appalachian Mountain Club (AMC) hut below the range. The views are quite fine, but the summits are very exposed to the weather.

This is Mount Webster (elevation 3,910 feet) as seen from Mount Willard (elevation 2,850 feet). In the foreground of this 1920 photograph is a group of hikers traveling by means of horse-drawn wagon. Mount Webster was once called Notch Mountain but was renamed for New Hampshire native Daniel Webster, the great 19th-century orator, senator, and secretary of state.

This vista was opened in 1931 at a point one and a half miles up the Champney Falls Trail from the Swift River Road, which is now the Kancamagus Highway. This spot is located on the east side of the Presidential Range, with the following mountains in view from left to right: Mounts Carrigian (elevation 4,700 feet), Anderson (elevation 3,740 feet), Owl's Cliff (elevation 2,940 feet), Tremont (elevation 3,371 feet), Willey (elevation 4,285 feet), Nancy (elevation 3,926 feet), and Bartlett (elevation 2,661 feet) and Bear Mountains (elevation 3,220 feet).

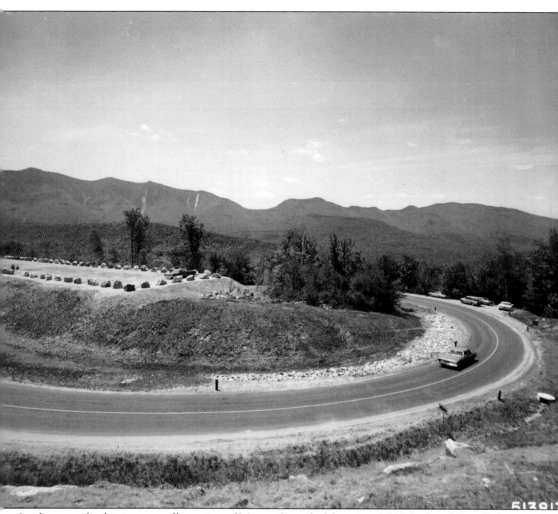

Looking south, this is an excellent view of Mount Osceola (elevation 4,340 feet) and Scar Ridge (elevation 3,774 feet) at horseshoe curve on the Kancamagus Highway. Mount Osceola is considered the highest peak in the region. It is a narrow, steep-sided ridge with a number of slides in its valley and is very impressive when seen from the outlooks along the western half of the highway. Scar Ridge runs northwest, parallel to the Hancock Branch and the Kancamagus Highway, and ends with a group of lower peaks above the village of Lincoln, home to Loon Mountain (elevation 3,065 feet), a major ski area in the Pemigewasset Valley.

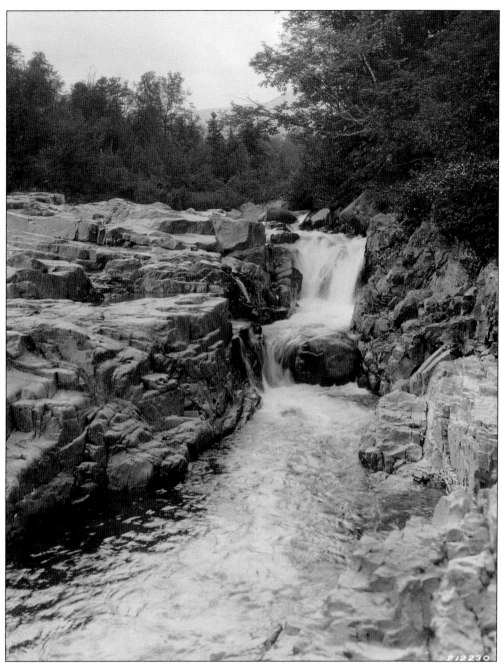

This rushing mountain cascade, known as Rocky Gorge, is seen from the Kancamagus Highway. It is interesting to learn that the highway was named for an early chief of the Penacook Confederation, Kancamagus, who led the final uprising between his people and the early white settlers. In the 1689 raid on Dover, before the Indians retreated to Canada, this scenic highway through the White Mountain National Forest was constructed with the combined efforts of the New Hampshire Department of Public Works and Highways, the US Bureau of Public Roads, and the US Forest Service. The road was opened between Conway and Lincoln in 1959. The scenic road opened the Swift and the East Branch of the Pemigewasset River watersheds for increased public use.

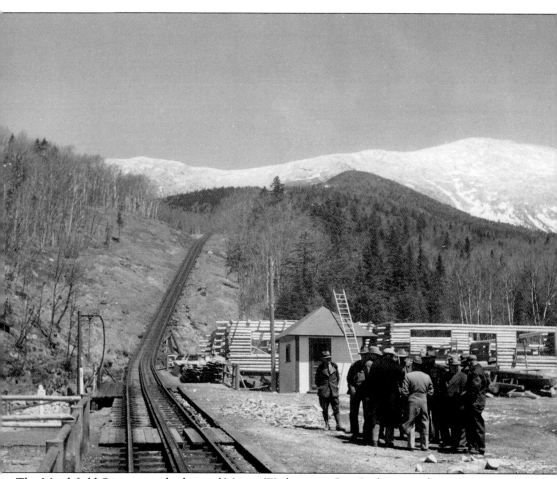

The Marshfield Station, at the base of Mount Washington Cog Railway, is where passengers would board the train for the three-mile trip to the summit of the mountain. A group of forest officers are about to inspect hazard reduction work on the Cog Railway right-of-way. The national forestland is beyond the building. The Cog Railway, completed in 1869 for $139,500, was built through the genius and enterprise of Herrick and Walter Aiken of Franklin and Sylvester Marsh of Campton. Made safe by toothed wheel and ratchet, the Mount Washington Cog Railway is the second steepest in the world and the first of its type. It was from here that the curious little inclined railroad began its way to the summit of Mount Washington. Over these many years, thousand of visitors have come to ride the railway to the summit. On August 27, 1869, Pres. Ulysses S. Grant and his family rode on the Cog Railway to the summit and were greeted by Sylvester March. This photograph was taken on June 18, 1939.

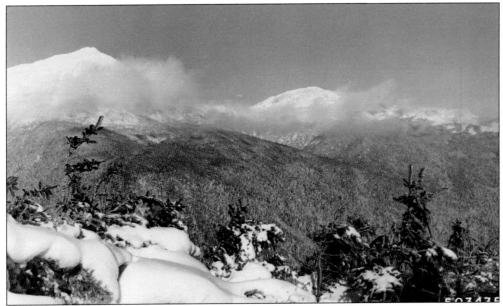

Mounts Adams and Madison in the Presidential Range are seen in their winter majesty from the Mount Washington Auto Road. Mount Adams is the second highest of the New England summits and is considered to have a greater variety of interesting features than any other New England mountain. Mount Madison is the farthest northeast peak of the Presidential Range. Both mountains have inspiring views across the Great Gulf.

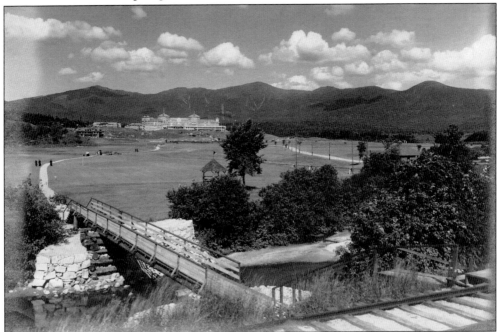

This is a majestic view of the Presidential Range with Mount Washington in the center and the Mount Washington Hotel at the base of the mountains. The hotel was opened to the public in 1902 and is one of the largest and most fashionable resorts in the White Mountains. From its grounds is one of the finest views of Mount Washington and the sister peaks.

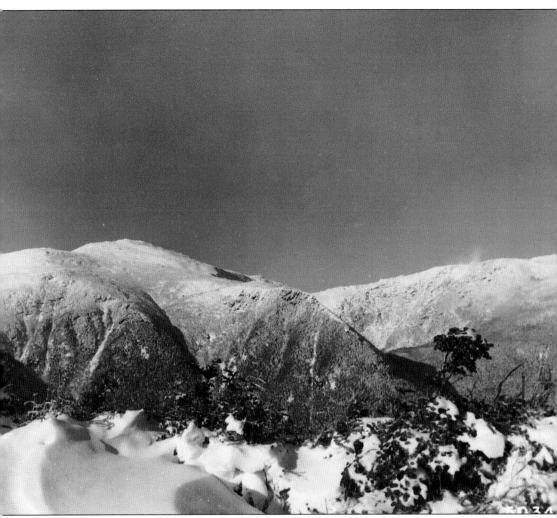

The Presidential Range, as seen from the Auto Road on the east side of Mount Washington, creates a dazzling skyline view. Mount Jefferson, with a portion of Mount Adams, is seen on the right of the range. From the summit of Mount Washington, visitors may gaze as far as the Atlantic Ocean in Portland, Maine, and as far west as Lake Champlain. To the south is beautiful Lake Winnipesaukee, and to the north is the distant outline of Lake Memphremagog. It should be noted that the White Mountain National Forest has established a number of forest protection areas (formerly known as restricted-use areas) where camping and wood or charcoal fires are prohibited throughout the year. However, since there are often major changes from year to year, one should obtain current information from White Mountain National Forest officials.

Samuel H. Goodhue, chairman of the AMC Hut Committee, is seen addressing a group at the Mizpah Spring Hut dedication. Mizpah, "pillar in the wilderness," is an appropriate name for this hut location. It is nestled on the southern flank of Mount Clinton (elevation 4,275 feet) and overlooks the Montalban Range, which is at the junction of the Webster Cliff Trail and the Mount Clinton Trail near the Mizpah Cutoff. The hut was built in 1964—one of the newest AMC huts finished in 1965. It sleeps 60 people in eight bunk rooms. This hut is open to the public from mid-May to mid-October. Pets are not permitted in the hut. There are, however, camping sites nearby.

Two

THE GREAT GULF WILDERNESS

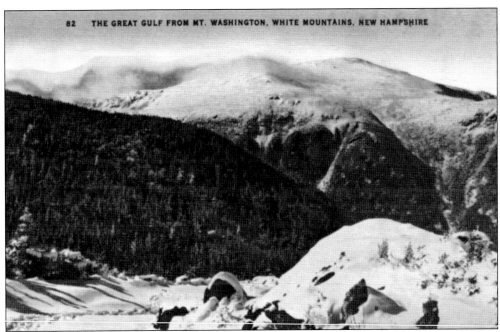

Looking from Mount Washington and the Presidential Range, the Great Gulf Wilderness can be seen. The gulf, which is settled between Mount Washington and the Northern Peaks and drained by the West Branch of the Peabody River, is the largest cirque in the White Mountains. The first recorded observation of the Great Gulf was by Darby Field in 1642, and the name probably had its origin in 1823 from a casual statement made by Ethan Allen Crawford, who lost his way one day and came to the edge of a great gulf.

Looking south from the side of Mount Adams, the Auto Road up Mount Washington is seen on the farther ridge. The head wall, bounded on the south by the slopes of Mount Washington and on the west by the summit ridge of Mount Clay, rises about 1,100 to 1,600 feet above the bowl-shaped valley. The views from its walls and from points on its floor are considered the best in New England, and steep slopes and abundant water results in a great number of cascades. The Great Gulf Wilderness is a protected area encompassing the cirque of the Great Gulf and is part of the National Wilderness Preservation System. Established in 1964 and designated by the 1964 Wilderness Act, the Great Gulf is New Hampshire's oldest and smallest wilderness area, comprising 5,552 acres.

This is an aerial view of the Great Gulf Wilderness from above Nelson Crag. Looking north to Mount Adams is Mount Jefferson at the far left. A section of the Mount Washington Auto Road is seen in the foreground. The Auto Road from the Glen House site on Route 16 to the Mount Washington summit, often called the Carriage Road, was constructed between 1855 and 1861. The beginning of the road (Glen House) crosses the Peabody River and starts the long climb to the summit. It continues to the tree line and passes the site of the Halfway House (elevation 3,840 feet), where there is a magnificent view to the north. Continuing up the road for a short distance, the Great Gulf is located on the right. The Tuckerman Ravine Trail enters on the left just below the parking lot, at about eight miles from which the summit buildings are located. Today, vehicles are charged a toll at the foot of the mountain. The road climbs the northeast ridge named for Benjamin Chandler, who died of exposure on the upper part in 1856.

This is the Great Gulf Wilderness as seen from Six Husbands on Jefferson's Knee. This wild, rough trail provides a magnificent view of the inner part of the Great Gulf. The forest that fills the bottom is so dense it prevents the adjacent peaks from being seen. Here, only the low, lulling voice of the mountain stream can be heard in the distance. This is an inspiring view into the depth of the Great Gulf (once known as the Gulf of Mexico) two miles in length, a mile wide, and 1,500 feet in depth—another glacial cirque. Partly surrounding the gulf are Mounts Jefferson, Adams, and Madison of the Presidential Range.

Three

THE GREAT NORTH WOODS

White Mts. N.H., Lancaster.

The Great North Woods, a remote northern tip of New Hampshire, is known by the residents as the "land up above," a place of lakes, rivers, and abundant forests. Portions of the region are part of the White Mountain National Forest. It is interesting to note that the town of Lancaster, founded in 1763 in the Great North Woods, lies on the bed of glacial Lake Coos, which was formed as the glacier receded 14,000 years ago. Today, the Connecticut River flows along the bottom of the ancient lake. This is the gateway to the Great North Woods.

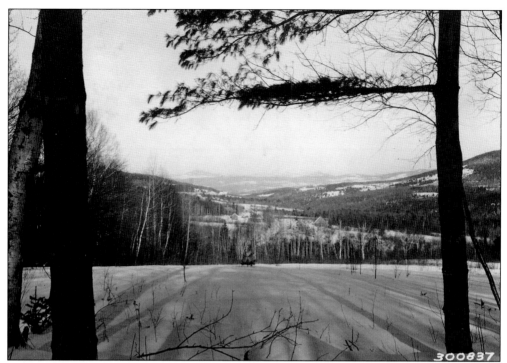

A view of the Ammonoosuc Valley, as seen in March 1935, is clearly visible from the top of the last hill on North and South Road, which is located near the base of Mount Washington and the Presidential Range. The headwaters of the Ammonoosuc River, a Connecticut River tributary, flow across the Fabyan flats.

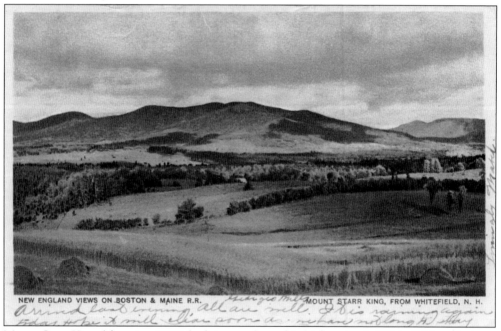

NEW ENGLAND VIEWS ON BOSTON & MAINE R.R. MOUNT STARR KING, FROM WHITEFIELD, N. H.

Mount Starr King (elevation 3,919 feet) is seen from this high point in Whitefield, well above the valley of the Israel River.

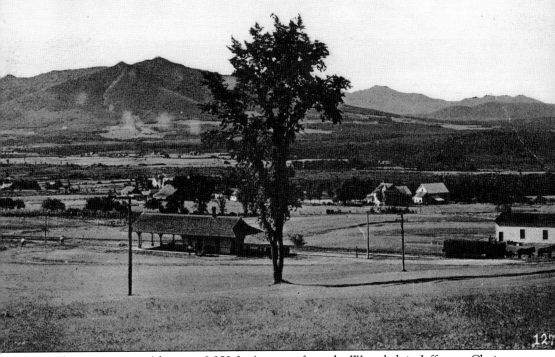

Cherry Mt. from the Waumbek, Jefferson, N. H.

This is Cherry Mountain (elevation 3,258 feet) as seen from the Waumbek in Jefferson. Choice vistas are open from the mountain, including Starr King and Jefferson Hill. Cherry Mountain is a prominent peak located in the town of Carroll. It is heavily wooded, with a conspicuous large scar on its northwestern slope, a reminder of a White Mountain tragedy. Here, on July 10, 1885, an avalanche of rocks and trees crashed from Owl's Head Peak, destroying everything in its path. For two miles, it roared down the mountainside, carrying away the home of Oscar Stanley at the base of the mountain, killing some of his cattle, and fatally wounding one of his farmhands. It was from a tree on this mountain that Timothy Nash discovered Crawford Notch in 1771.

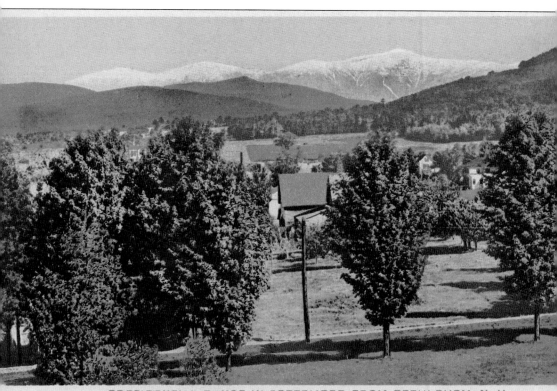

PRESIDENTIAL RANGE IN SEPTEMBER FROM BETHLEHEM, N. H.

The Presidential Range, as seen from Bethlehem in September, stands as a beacon to the North Country and the White Mountains. Mount Washington is occasionally visible 75 miles away from the Atlantic. In 1508, Giovanni da Verrazano, voyaging between the 14th and 15th parallels, probably saw the White Mountains; he wrote that he saw "high mountains within the land." Nearly a century later, Samuel de Champlain, cruising along the New England coast and reaching Casco Bay, reported, "From here large mountains are seen to the west." In his map of New France, he designated mountains in this general region. Compared to mountains in the Rockies, the White Mountain elevation above sea level is not great, but they have the scenic advantage of being higher above the immediate surrounding country. The level of the valley ranges from 500 to 1,000 feet; Mount Washington towers a mile above the latter level. It is this feature that gives the White Mountains unusual impressiveness.

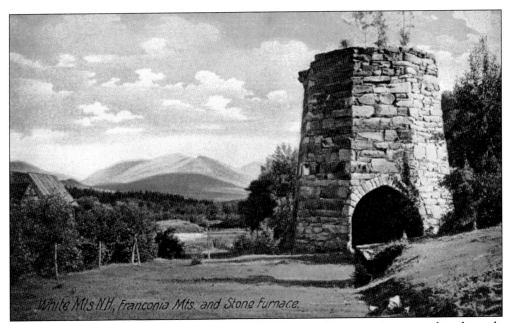

White Mts N.H., Franconia Mts. and Stone Furnace.

In the town of Franconia is seen the remains of an old iron furnace as it appeared in the early 1900s. In the early 19th century, the Franconia Iron Works processed iron from local mines to make goods. In back of the tower, there are traces of the road down the embankment where the ore was hauled from Iron Mountain, or Ore Hill, as they called it then. In the distance are the Franconia Mountains.

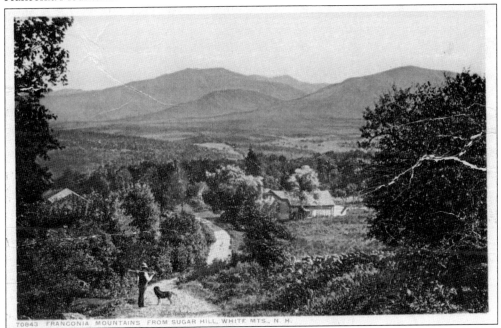

70843 FRANCONIA MOUNTAINS FROM SUGAR HILL, WHITE MTS., N. H.

The Franconia Mountains are seen from Sugar Hill. The Franconia and Twin Ranges are two high ridges that form a great horseshoe enclosing the western lobe of the Pemigewasset Wilderness. This lobe is drained by Franconia and Lincoln Brooks, which almost encircle the long, wooded ridge called Owl's Head Mountain.

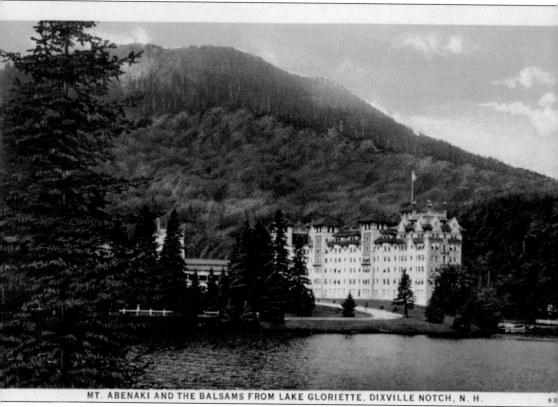

Above the lake and behind the towers of the Balsams Hotel is Mount Abenaki (elevation 2,723 feet). The name Abenaki is appropriate, as this was a haunt of the Indians of that tribe. The Balsams, Lake Gloriette, and Dixville Notch have become popular landmarks in the Great North Woods. Beyond Dixville Notch is an intervale that seems to have been scooped out by some giant hand. Across Lake Glorietta are the Swiss-like buildings of one of New Hampshire's best-known hotels, the Balsams. The Balsams has outlived most of the 19th-century hotels in the White Mountains of New Hampshire. Since 1960, the Balsams Hotel has had the distinction of being the first voting poll in the nation to cast its vote for national and state elections. The Balsams continues to thrive today as a first-class resort hotel in the Great North Woods.

The Balsams Wilderness Ski Area is one of the more popular ski attractions and resorts in the White Mountains. The Balsams Resort refers to the mountain as Wilderness Ridge or Table Rock. The west trailhead, sometimes called the Table Rock Hiking Trail, also designated as part of the Dixville Heritage Trail loop, is .4 miles west of the main entrance to the Balsams, near a pedestrian crossing sign. Beginning at the west trailhead, the trail follows a cross-country ski trail and climbs moderately to a higher elevation. In 1966, the hotel ownership decided to open the hotel for the winter season. Raoul Jolin was hired to oversee the design and construction of the ski area and base lodge. Warren Pearson was hired as ski school director. Since the opening of the area, it has become a first-class drawing card for the resort and the North Country.

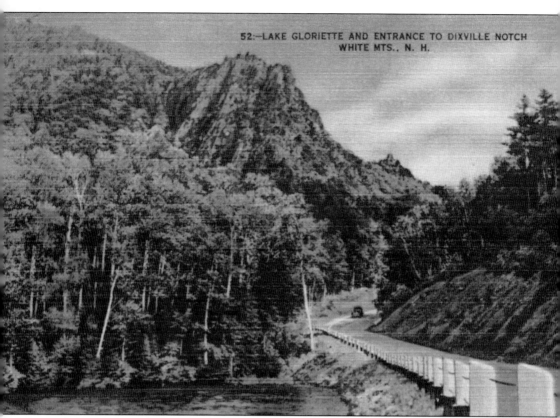

52:—LAKE GLORIETTE AND ENTRANCE TO DIXVILLE NOTCH
WHITE MTS., N. H.

Lake Gloriette and the entrance to Dixville Notch have become major attractions for visitors to the Great North Woods. Dixville Notch was originally an old Indian pass known as the Coos Trail that connected the Androscoggin and Connecticut Rivers. Dixville is the northernmost notch in the state of New Hampshire. This natural formation is known as Pulpit Rock.

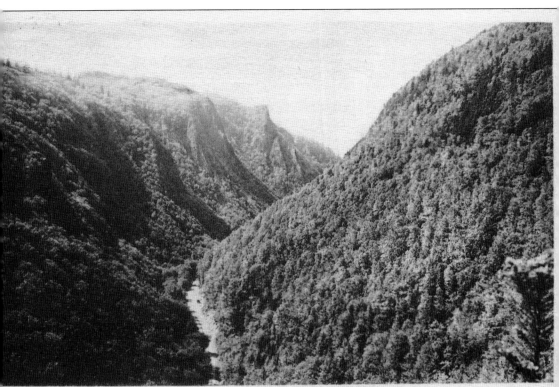

Road through Dixville Notch, N. H. Looking west from Pulpit Rock, near the Balsams.

Looking west to east from Pulpit Rock, near the Balsams, is the road through Dixville Notch, as seen here in 1920. No other two miles in New Hampshire surpasses Dixville Notch in its Alpine ruggedness. The notch was described in the 1938 *American Guide to the Granite State* as follows: "In general it may be said that the Notch looks as if it had been produced by a convulsion of nature, which broke the mountain ridge from underneath, throwing the strata of rocks up into the air, and letting them fall in all directions. The result is that the lines of stratification in the solid part of the hills point upward, sometimes perpendicular, like falling spires of cathedrals, stand out against the sky." The highest point of elevation is 1,990 feet through the Dixville Notch, and here, high on a cliff, is a profile, sometimes called by the name of Daniel Webster, although it may be difficult to trace its resemblance to that distinguished son of New Hampshire.

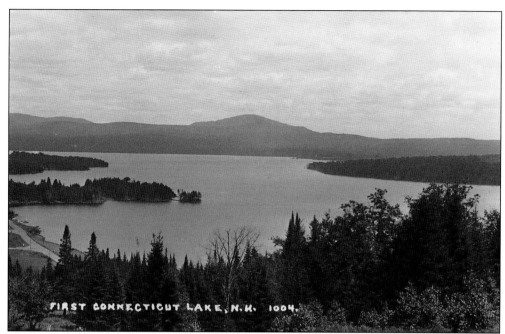

The First Connecticut Lake is beautifully situated in Pittsburg. It is 5.5 miles long and 2.5 miles across at its widest point. Much of the land in the Connecticut Lakes Region is privately owned. While the owners do not discourage the use of their lands for hiking, they do request that these activities be limited to the daytime hours.

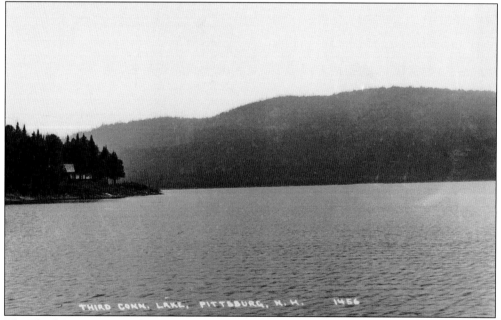

The Third Connecticut Lake in Pittsburg is well stocked with Atlantic, landlocked, and Chinook salmon, as well as rainbow and brook trout. Near the highway are numerous camps for fishermen and hunters. Use of registered vehicles is limited to those roads that are not gated or posted for closure.

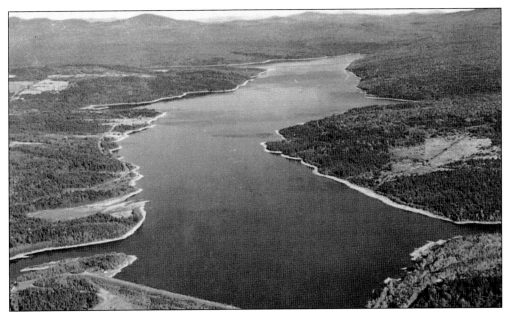

Lake Frances (2,081 acres) is located in Clarksville. Lake Frances, although man-made, has the same unspoiled charm of other bodies of water in the Connecticut Lakes Region of New Hampshire. A high dam at Pittsburg created Lake Francis, the lowest in a series of lakes in the area of the state. These lakes are the largest bodies of water in New Hampshire north of the Presidential Range.

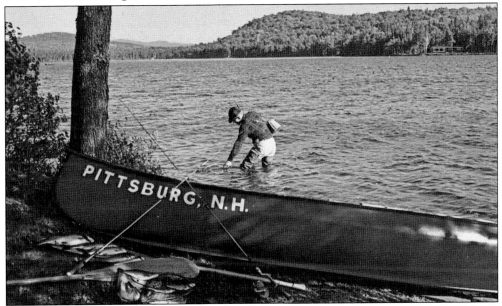

Back Lake is a secluded body of water surrounded by low hills. It is known for its good fishing. Pittsburg is the northernmost and largest township in the Great North Woods. For many years after the Revolution, this Connecticut Lakes Region was claimed by both the United States and Canada. On July 9, 1832, the settlers formed their own local government, and the section became known as Indian Stream Territory. The tiny state existed for three years. In 1840, the town of Pittsburg was incorporated, and via the Ashburton Treaty (1842), the region in the Great North Woods was awarded to New Hampshire.

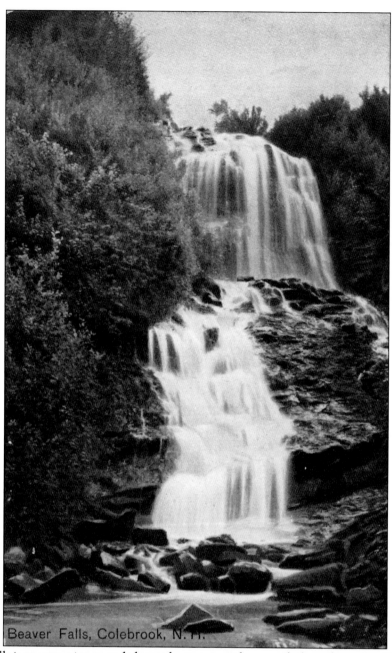

Beaver Falls, Colebrook, N. H.

Beaver Falls is an attractive cascade located approximately one mile from the town of Groveton. The town is considered an important settlement in the Great North Woods. On the flat ground of the river valley near the junction of the upper Ammonoosuc and Connecticut Rivers is the center for the town. In 1786, a ferry over the Connecticut River and a branch of the Ammonoosuc River, which runs into the Connecticut River in Northumberland, was approved and authorized over Little Falls on the Connecticut River. In 1799, another bridge built across the Ammonoosuc River was destroyed by a freshet the same year. With the arrival of the railroads in 1850, Groveton achieved importance. A large paper mill replaced the sawmills and is still considered a major industry of the town. Beaver Falls is most impressive for its beauty.

Four

THE PEMIGEWASSET WILDERNESS

This is a peaceful scene in 1910 at the entrance to Franconia Notch in the Pemigewasset Wilderness. The Pemigewasset Wilderness has an area of 45,000 acres. It was established in 1984 as a federally designated wilderness area in the heart of the White Mountains. In the Pemigewasset Wilderness, the Franconia Notch (altitude 1,950 feet) is a major mountain pass through the White Mountains. The Pemigewasset Wilderness is considered to be one of the more popular recreational areas in the Granite State.

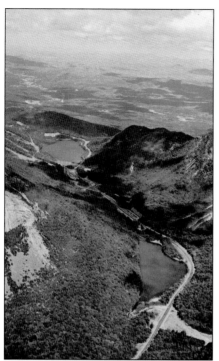

A striking aerial view of Franconia Notch is seen here, with Profile Lake and Mountain in the foreground. The Old Man of the Mountain (not seen) was located high up on the ledges at left. Echo Lake and Bald Mountain are located in the background, with slopes of Mount Lafayette (elevation 5,260 feet) at the right and the Franconia Notch Parkway (Interstate 93), which passes through the Franconia Notch (as seen in the center of the picture).

Looking north through the Pemigewasset Valley to Franconia Notch, as seen from US Route 3 at Fairview, is the magnificent vista of Cannon Mountain (elevation 4,100 feet) on the far left and Mount Lafayette (elevation 5,260 feet) in the distance on the right. The river in the center foreground is the Pemigewasset. The river flows straight to the south from Profile Lake, descending more than 1,500 feet before it reaches the town of Plymouth.

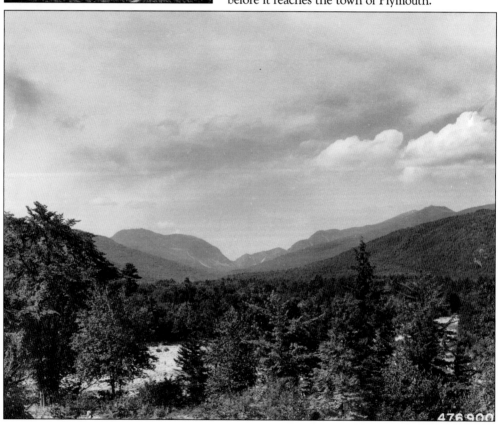

A winter scene taken on Cannon Mountain (elevation 4,100 feet) frames Mount Liberty (elevation 4,459 feet) in the background. The peaks of Mount Liberty and Mount Flume are connected to each other and to Little Haystack Mountain by long, graceful parabolic ridges. Both these peaks have very fine views in all directions.

Again from Cannon Mountain is a spectacular view looking across Franconia Notch toward Mount Lafayette (elevation 5,260 feet). Eagle Cliff (elevation 3,420 feet) and Eagle Pass are located in the center. One of the grandest wonders at the southern gateway is Franconia Notch, which is a deep, narrow canyon that has been eaten away by a mountain brook.

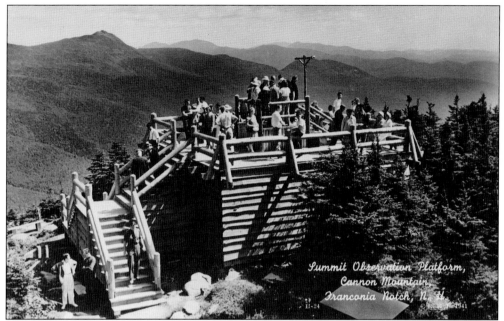

On the summit of Cannon Mountain is the observation platform, which is very popular during the warm seasons. Mountain peaks and ranges in four states and Canada may be seen from the summit. This dome-shaped mountain is famous for its magnificent profile, the Old Man of the Mountain, and for its imposing east cliff.

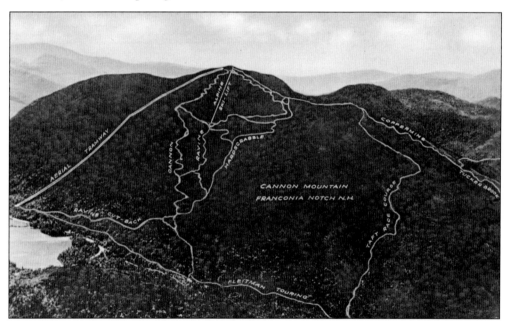

The Cannon Mountain ski area in Franconia Notch is one of the more popular winter destinations in the North Country. The tramway was christened on June 28, 1938, with a capacity of 28 people. During the 1950s, the system of four downhill ski trails, starting at an altitude of 4,200 feet, was served by a mile-long aerial tramway and the highest Alpine ski lift in the East at that time. This photograph was taken during the 1940s.

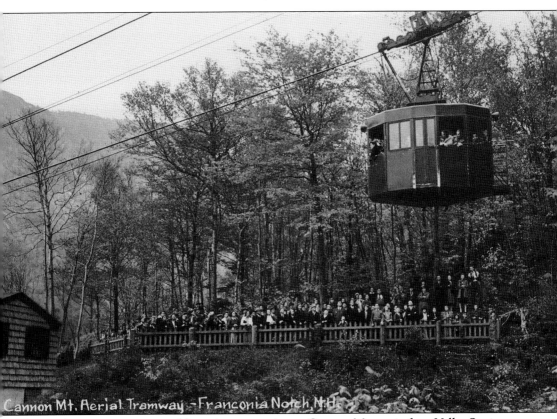

Cannon Mt. Aerial Tramway - Franconia Notch, N.H.

The aerial passenger tramway cable car is seen starting up Cannon Mountain from Valley Station. It was Gov. John G. Winant who selected Cannon Mountain as a state recreation center for skiing. On June 17, 1937, the state passed a bill calling for $250,000 to finance the construction of the tramway. The Valley Station, the lower terminal of the mountain tramway, was built some 250 feet from the old roadway. This service operates year-round, stopping only when winds reach 40 miles per hour. This tramway was replaced by the existing one in 1980. The Cannon Mountain Ski Area is located in the Franconia Notch adjacent to the wilderness in the White Mountain National Forest.

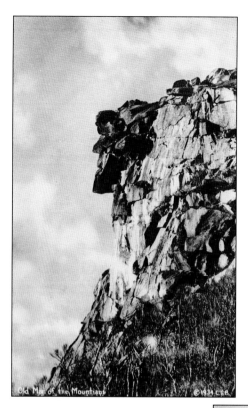

Old Man of the Mountians ©1934 C.T.G.

Shown here is a close-up of the profile of the Old Man of the Mountain, considered to be the most perfect natural stone face in the world. The profile was located on the south end of Cannon Mountain, known as Profile Mountain (elevation 1,400 feet), above beautiful Profile Lake. On May 3, 2003, the profile fell from the face of the mountain. Sadly, the Old Man of the Mountain is missed. The profile is located in the Franconia Notch adjacent to the wilderness in the White Mountain National Forest.

The Old Man of the Mountain on Profile Mountain is pictured from the parking lot near the parkway in the early 1930s. Up until the collapse of the Old Man's profile on May 3, 2003, no scenic feature of the White Mountains was so photographed by amateurs. The usual published photographs are either taken by telephoto lenses or are enlargements.

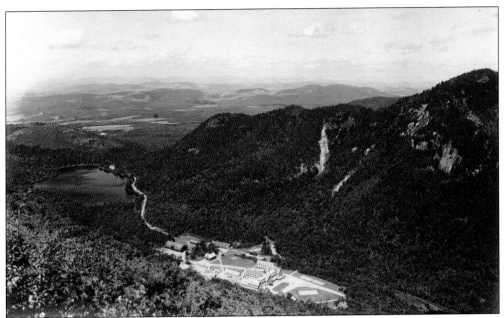

From the Old Man's forehead, the view faces down the notch where the famous Profile Hotel once stood during the early 1930s. The Great Stone Face, which consisted of five granite ledges pushed out from one of the highest cliffs of Franconia Notch, was one of the most uniquely attractive scenic features of the East. The expression of the profile was noble, and those who ever saw it with a thundercloud behind it might carry away the grandest impression ever made on a tourist.

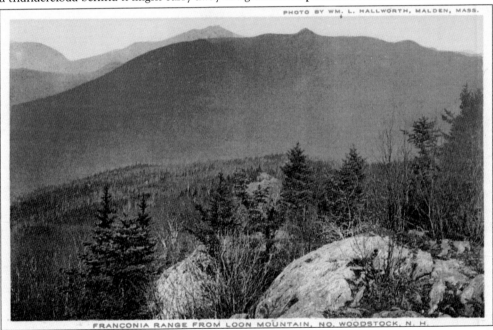

Franconia Range, as seen from Loon Mountain (elevation 3,065 feet) and located in North Woodstock, highlights Mount Lafayette in the notch. The Franconia Range ranks second among those of the White Mountains, only in elevation. Its sharp, narrow ridge contrasts strikingly with the broad, massive Presidential Range.

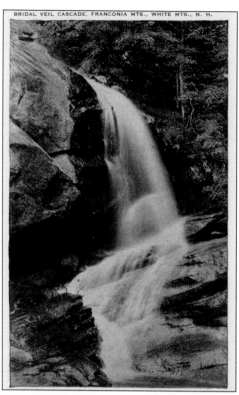

BRIDAL VEIL CASCADE, FRANCONIA MTS., WHITE MTS., N. H.

The trail to the Bridal Veil Cascade begins on Coppermine Road and leaves the east side of New Hampshire Highway Route 116 just south of the Franconia Airport. Climbing at an easy to moderate grade, the trail joins Coppermine Brook, then crosses to the south side of the bridge, passes the White Mountain National Forest Coppermine Shelter, and ends at the base of the beautiful Bridal Veil Cascade.

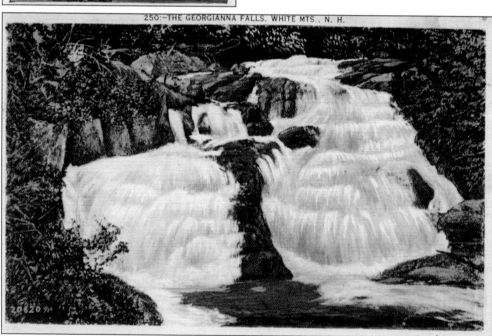

250:—THE GEORGIANNA FALLS. WHITE MTS., N. H.

The Georgianna Falls are alive with nature's vibrant energy. The falls are a series of cascades on Harvard Brook that end in a pool. Above Georgianna Falls, there are several cascades, which terminate in the Harvard Falls farther up the stream. The falls are also known as the Upper and Lower Georgianna Falls, which may be more historically correct.

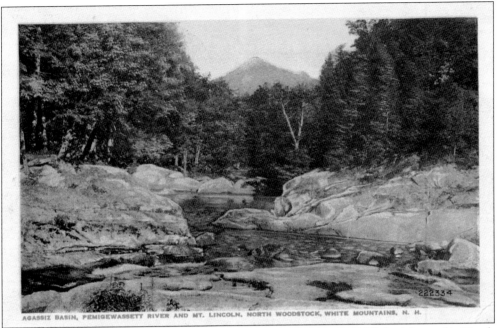

AGASSIZ BASIN, PEMIGEWASSETT RIVER AND MT. LINCOLN, NORTH WOODSTOCK, WHITE MOUNTAINS, N. H.

The Agassiz Basin, Pemigewasset River, and Mount Lincoln (altitude 5,089 feet), located in North Woodstock, are considered must-see for visitors. Agassiz Basin is located in the bed of the Lost River, four miles southeast of the Lost River Gorge. Two bridges cross the gorge, connected by a short path on the south bank. The basin takes its name from a naturalist, Louis Agassiz, who visited the region while doing research in 1847 and 1870.

This is an excellent panoramic view from the summit of Mount Osceola (elevation 4,340 feet). This view is equal to that from Mounts Carrigain (elevation 4,700 feet) or Willey (elevation 4,285 feet) for its wide sweep on the Pemigewasset Forest and surrounding peaks in the White Mountains.

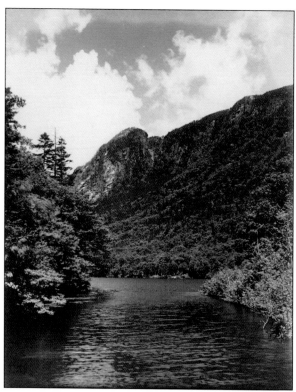

Eagle Mountain Cliff is located on the facade of Mount Lafayette. It is a great spur of Mount Lafayette running to the west and northwest. Profile Lake, located at the foot of Profile Mountain, is completely surrounded by forest. The pond has been called the Old Man's Washbowl. This body of water is the source of the Pemigewasset River, which flows south to join the Merrimack River.

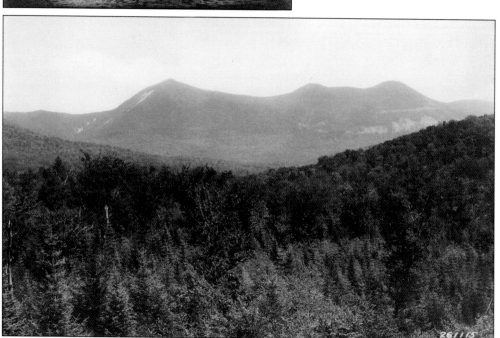

This is a view of the Mount Tripyramid North Peak (elevation 4,180 feet). Mount Tripyramid consists of the following: the Middle Peak (elevation 4,140 feet), North Peak (elevation 4,180 feet), North Slide, South Peak (elevation 4,100 feet), and South Slide, as seen in this view from Waterville Golf Links.

50

The Flume, considered the greatest wonder at the southern gateway of the Franconia Notch, is a deep and narrow canyon created where the brook has eaten through these 700-foot granite ledges near the base of Mount Flume (elevation 4,328 feet). This view was taken during the early 1900s. The Flume is located in the Pemigewasset Valley adjacent to the wilderness in the White Mountain National Forest.

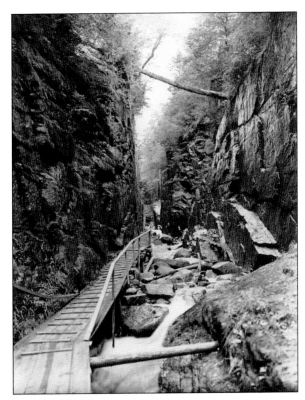

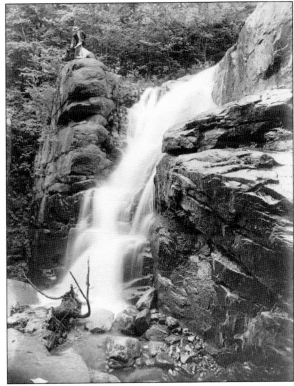

The Avalanche Falls (Flume Cascade), located at the upper end of the Flume, is vibrant and alive as it rushes down the granite rocks. In the Flume are broad ledges worn smooth by the action of the water and scoured by an avalanche in June 1883 that swept away the once famous suspended boulder.

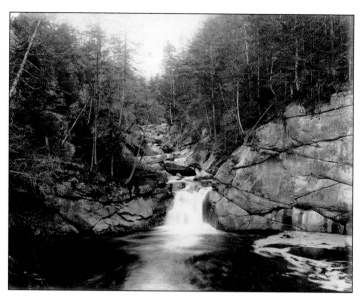

Within the Pemigewasset Wilderness, a half-mile east of the former location of the Flume House, resides a large, 50-foot-deep pothole of water known as the Pool. High ledges clustered with alpine flowers and ferns rise above the Pool. Today, the Flume attracts thousands of visitors each year.

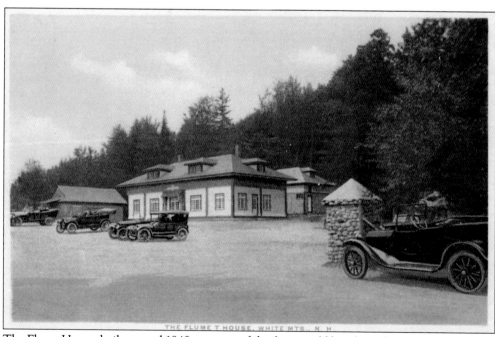

THE FLUME T HOUSE, WHITE MTS., N. H.

The Flume House, built around 1848, was one of the famous old hotels in the White Mountains. Burned in 1871, a successor was built that suffered the same fate in 1918. From this point was an excellent view looking northward into Franconia Notch. The Tea House is not the same as the hotel. This rare photograph was taken in 1921.

Paradise Falls is located at Lost River in North Woodstock. It is written that the Lost River derived its name from the fact that it has a way of losing itself during its journey beneath the rocks, which were chiseled by frost from the side of the mountain to the north.

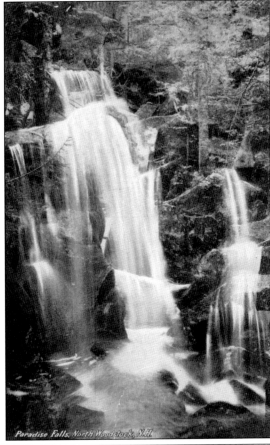

Paradise Falls, North Woodstock, N.H.

The Kinsman Notch at Lost River lies within the Moosilauke Mountain (elevation 4,802 feet) and the Kinsman Range, forming a natural pass between the Pemigewasset and Connecticut River Valley. Kinsman Notch received its name from an early settler, Asa Kinsman, who hewed his way through the notch with an ax.

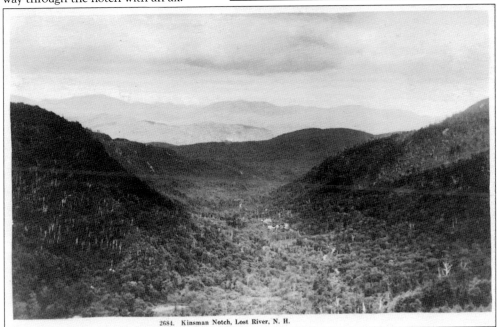

2684. Kinsman Notch, Lost River, N. H.

Mount Tripyramid is seen in the far distance, and at the foothill is the village of Campton in the White Mountains. Mount Tripyramid is the rugged and very picturesque mountain that forms the east wall of the Waterville Valley and also overlooks Albany Intervale, which lies to the north and east.

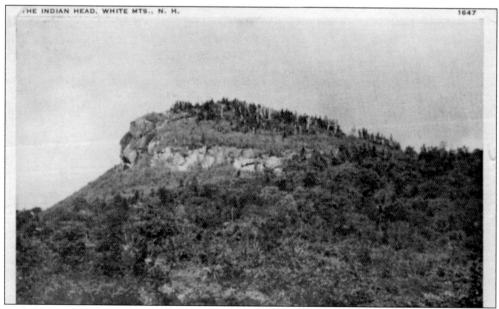

High above the clearing is the Indian Head, an impressive profile formed by a ledge on Mount Pemigewasset (elevation 2,557 feet) in Lincoln. The mountainside's natural contour presents a sharp profile resembling that of an Indian's. The following measurements are provided by the White Mountain National Forest: "The head being 98 feet from the top of the foreground to the bottom of the chin. The forehead itself is 17 feet high; the nose, 42 feet long; the upper lip, 23 feet wide."

The observation tower located at the base of Indian Head in Lincoln is part of the Indian Head Resort. The observation tower included the 72-foot steel edifice when this picture was taken. The resort was originally a small village of uniform, English-type, single-story houses. This rare photograph was taken during the 1920s. The Indian Head is located in the Pemigewasset Valley adjacent to the wilderness in the White Mountain National Forest.

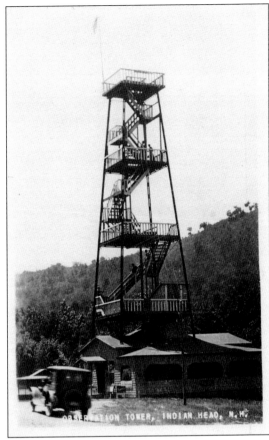

OBSERVATION TOWER, INDIAN HEAD, N. H.

The Franconia Mountain Range is clearly seen from the Indian Head Observation Tower. This spectacular mountain pass, traversed by a unique parkway, is known as the Franconia Notch Parkway (Interstate 93 and US Route 3). The parkway, which winds between the high peaks of the Kinsman and Franconia mountain ranges, is dominated by Cannon Mountain, lying principally within Franconia Notch State Park.

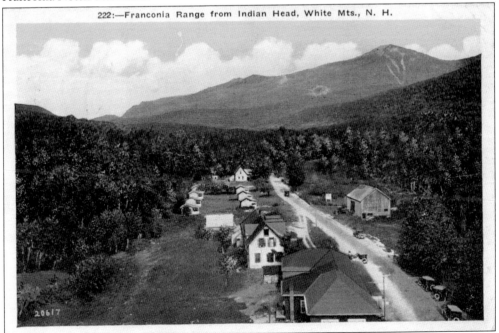

222:—Franconia Range from Indian Head, White Mts., N. H.

20617

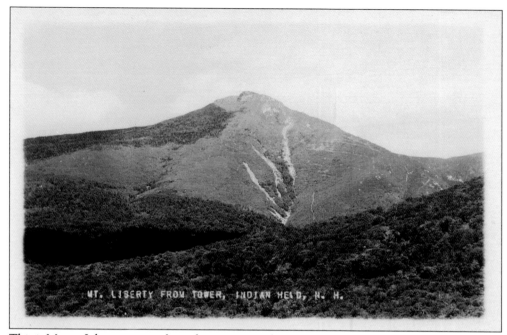

This is Mount Liberty as seen from the tower at Indian Head. This mountain is located south of Mount Lincoln (elevation 5,089 feet) and the Haystack (elevation 2,713 feet). The summit of the mountain is located approximately four miles from the Flume.

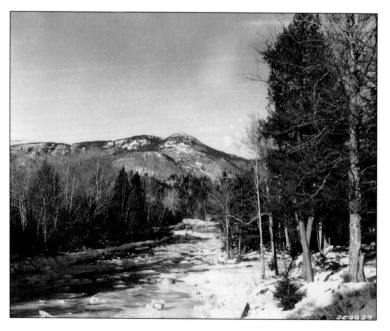

Mad River is located in Waterville Valley, the heart of the White Mountains. The walls of the valley are composed of Mounts Tecumseh (elevation 4,003 feet), Osceola (elevation 4,340 feet), and Tripyramid and Black Mountain (elevation 2,732 feet), more commonly known as Sandwich Dome.

Five

THE SANDWICH
RANGE WILDERNESS

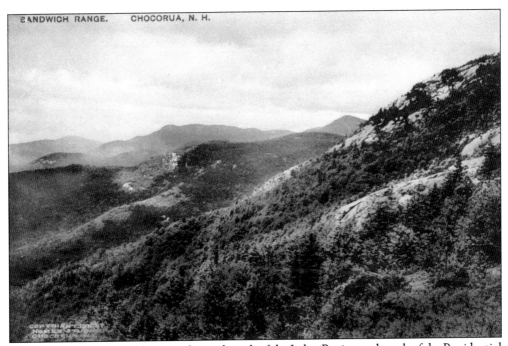

The Sandwich Range Wilderness is located north of the Lakes Region and south of the Presidential Range. The range extends for approximately 30 miles in an east-west direction from the Conways and the Saco River to Campton on the Pemigewasset River. The wilderness encompasses 25,000 acres, which was designated by the 1984 New Hampshire Act. The Sandwich Range Extension consists of 10,800 acres and was designated by the 2006 New England Wilderness Act.

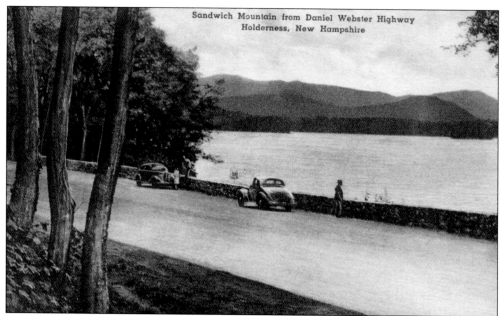

Sandwich Mountain from Daniel Webster Highway
Holderness, New Hampshire

Looking across Squam Lake and the Daniel Webster Highway in Holderness is an excellent view of the Sandwich Mountain Range (altitude 3,980 feet). Squam Lake—with an area of 6,767 acres, a length of six miles, and a width of approximately three miles—contains countless inlets, bays, and coves. The lake is divided into two sections, between which several long islands are parallel to one another.

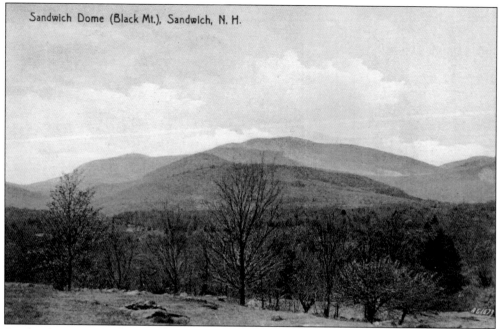

Sandwich Dome (Black Mt.), Sandwich, N. H.

Sandwich Dome (elevation 3,980 feet) is the westernmost major summit of the Sandwich Range; its ridge forms the south wall of Waterville Valley, which looks over the lower Mad River to the west. The Sandwich Mountains were once called the Black Mountains, a name that has also been applied to its southwest spur (elevation 3,500 feet).

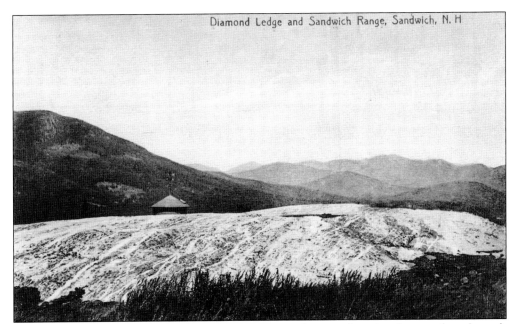

Diamond Ledge in the Sandwich Range was once a thriving location for travelers through Sandwich Notch from Waterville Valley to Center Sandwich. Industry was short-lived when the Diamond Ledge Mine was operating. The mine was opened in 1877. The gold proved elusive, and the mine closed a year later. Henry Pascoe was convinced that there was gold in the Diamond Ledge Hills, so in 1903, it was reopened and continued for three years.

Beede Falls (Cow Cave) is located in the town park on the Sandwich Notch Road just 3.4 miles from Center Sandwich. During the Great Depression, the Civilian Conservation Corps (CCC) developed the Cow Cave–Beede Falls area into a public park. The notch road will lead one past Mead Base (a Boy Scout Camp) and the new Bearcamp River Trail through the trailhead in the notch.

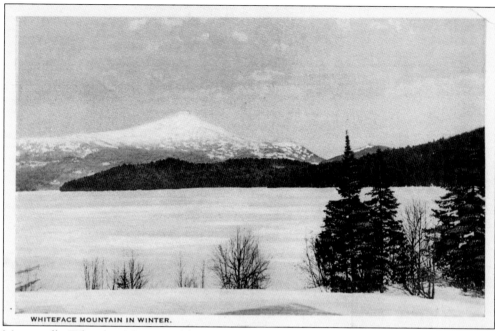

WHITEFACE MOUNTAIN IN WINTER.

Majestically, Whiteface Mountain (elevation 4,020 feet) is seen from Wonalancet. The Sandwich Mountain Range Wilderness is located in the western part of the town of Sandwich. The mountain received its name from the precipitous ledges south of the summit, which afford a majestic view from the mountain's top. The mountain-monarch, severe and hard, illuminates a white face set like fleece of gold and red.

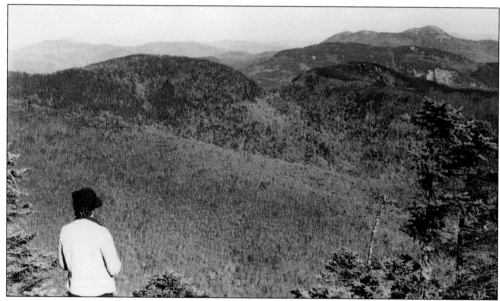

This is a view from Whiteface Mountain (elevation 4,020 feet) in Sandwich, looking east, with Mount Chocorua (elevation 3,500 feet) and its rocky summit in the distance. The legend relates to the mysterious death of Chocorua's son while in the care of a settler named Campbell. Suspicious of the cause, the Pequawket chieftain took revenge on the settler's family. In retaliation, Campbell killed Chocorua on the summit of the mountain now bearing the Indian's name.

Mount Chocorua (elevation 3,500 feet) and Lake Chocorua are considered two of the most photographed landmarks in the state. This image was taken in 1920. Mount Chocorua is seen framed by tall and densely growing pines. From the highway (Route 16) is an excellent view of the lake and mountain, which were named after Chief Chocorua of the Pequawket Indians.

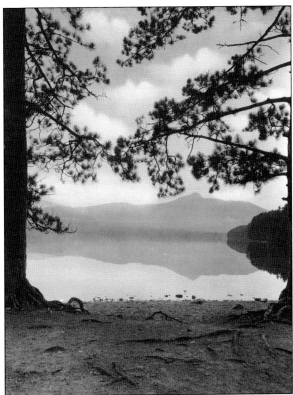

The summit of Mount Chocorua (elevation 3,500 feet), with its storm-beaten cone, is boldly visible on the east end of the Sandwich Mountain Range Wilderness. Mount Chocorua is one of the most dangerous peaks in the White Mountains. Many of the trails have ledges that are hazardous when wet or icy, and the summit and upper ledges are severely exposed to lightning during electrical storms.

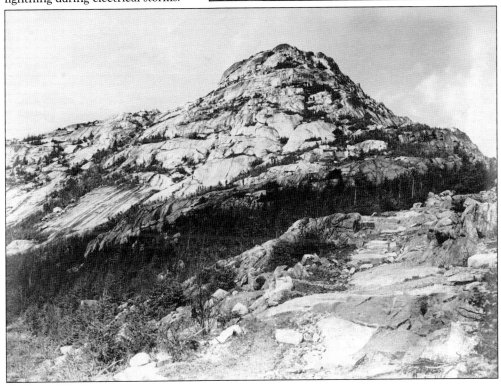

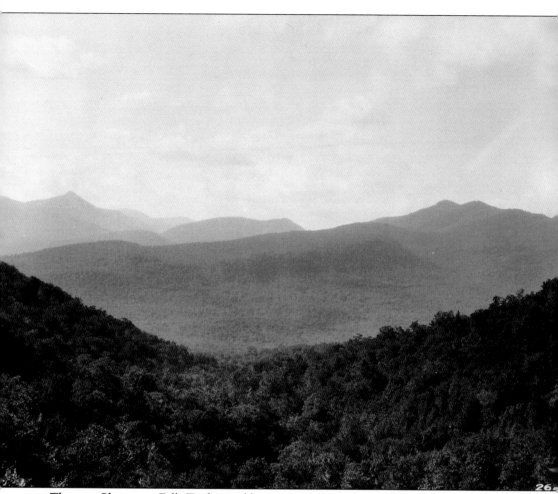

The new Champney Falls Trail is visible in its primitive, glorious beauty. This splendid view is visible to hikers on the Champney Falls Trail en route to or from Mount Chocorua (elevation 3,500 feet). From left to right are Owl's Cliff (elevation 2,940 feet); Mounts Tremont (elevation 3,371 feet), Willey (elevation 4,285 feet), and Nancy (elevation 3,926 feet); Bartlett Haystack Mountain (elevation 2,980 feet); and the Bear Mountains (elevation 3,220 feet). This view is approximately two miles up from the Swift River Road (Kancamagus Highway).

Six

NORTH CONWAY

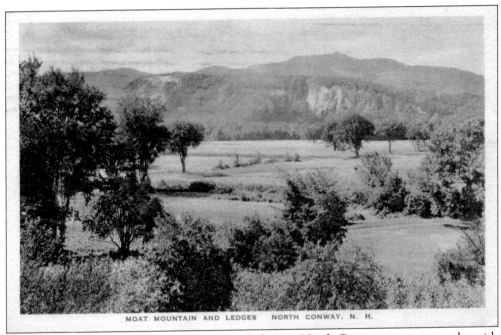

MOAT MOUNTAIN AND LEDGES NORTH CONWAY, N. H.

Moat Mountain (elevation 2,805 feet) and its ledges, in North Conway, are very popular with rock climbers who ascend them via two trails: White Horse Ledge Trail and Bryce Path. Moat Mountain is a long ridge that rises impressively to the west of the Saco River nearly opposite North Conway. The crest line of the ridge is approximately three miles long, which consists of the North and South peaks separated by shallow ravines.

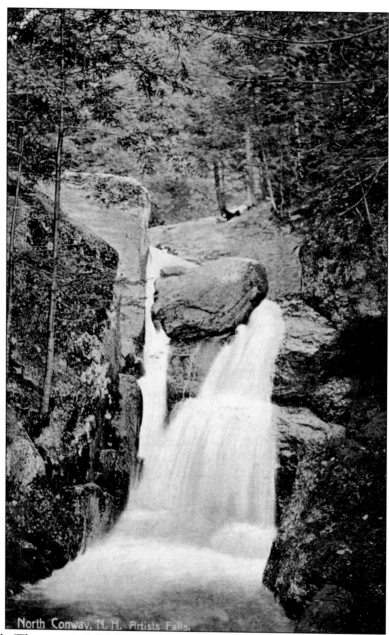

North Conway, N. H. Artists Falls.

Artist Falls (Thompson's Falls) lies near the White Horse Cliffs and Cathedral Ledge. These falls are interesting because of their association with Benjamin Champney, a landscape painter who probably did more than all of his fellow artists to make North Conway known to the outside world. Champney and seven other artists set out one day in the summer of 1851 to penetrate the forest and were rewarded by finding the falls. In 1850, Champney, a native of New Hampshire, discovered the artistic possibilities of the North Country region and established an art colony in North Conway. Many landscape painters of the Hudson River School came to his home, which he records in his autobiography: "In 1853 and 1854 the meadows and banks of the Saco were dotted all about with white umbrellas." From their work in this region, the group also became known as the White Mountain School.

Cathedral Ledge (elevation 1,159 feet) in North Conway stands prominently on the western side of the village. This massive ledge, a 700-foot vertical wall, was formed as a result of granite shearing. Cathedral Ledge, which provides a fine scenic view, is reached by trails from Echo Lake State Park. It may also be driven to via road.

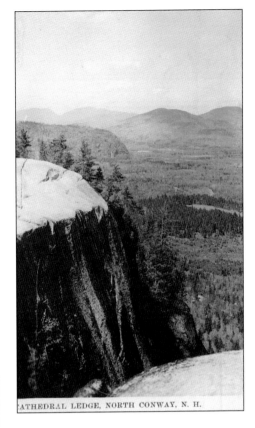

CATHEDRAL LEDGE, NORTH CONWAY, N. H.

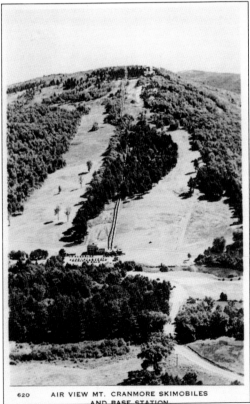

620 AIR VIEW MT. CRANMORE SKIMOBILES
AND BASE STATION

This is an aerial view of the Mount Cranmore (elevation 1,690 feet) Skimobile Base Station, a very popular ski resort located in North Conway. The base lodge may be reached in about 1.2 miles with about 1,100 feet of descent via ski trails. The first skimobile trestle ascended Mount Cranmore in 1939. The skimobile was a huge success. Today, the reputation of this ski school and Hannes Schneider (a professional skier from Austria who opened the school) has drawn thousands of skiers to Cranmore Mountain in North Conway.

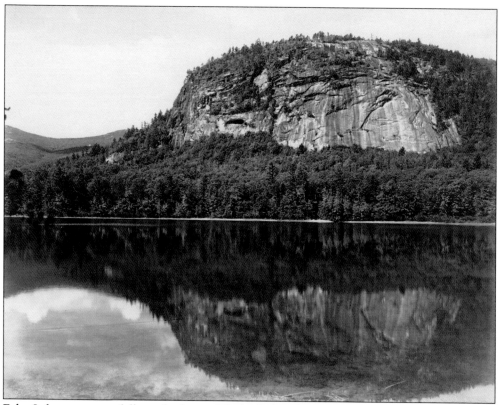

Echo Lake rests peacefully at the base of Cathedral Ledge in Conway. The ledge received its name from the cathedral-like arch formed by the cliffs. At the top of the ledge is a small cave known as the Devil's Den. There are marked trails to Cathedral Ledge and White Horse ledges, and Middle Moat Mountain (elevation 2,860 feet), being the central peak of the range, may be picked up at Diana's Bath.

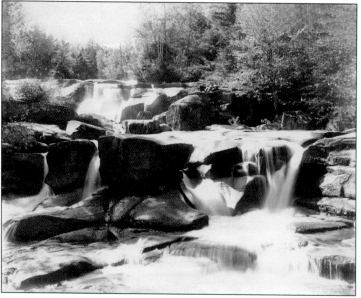

Diana's Bath is a striking rock formation on Cedar Brook descending from the Hopper on North Moat. Over a gentle sloping ledge worn smooth by the action of the stream, the clear water falls into a deep and rounded rock basin.

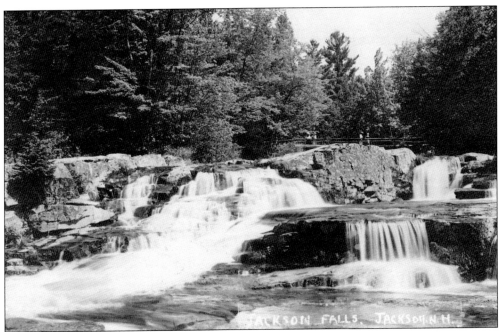

Jackson Falls is a beautiful and secluded glen with a series of cascades on the Wildcat River, a tributary of the Ellis River. Wildcat, well named, divides the village in two, and the mountain of the same name, with many summits, looms above it in the north. The falls is less than four miles from the Glen Railroad Station.

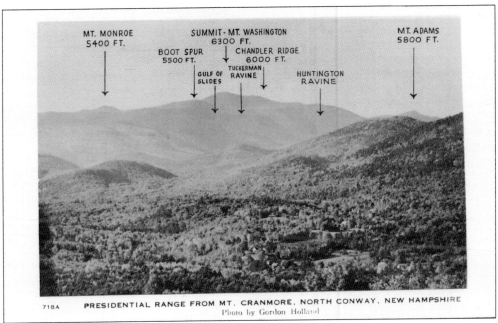

Looking northwest from Mount Cranmore (elevation 1,690 feet) in North Conway is one of the most beautiful views of Mount Washington and the Presidential Range. About 16 miles distant is the summit of Mount Washington. The intervale's charm is in its surroundings, where the southern Presidential Range fills the horizon.

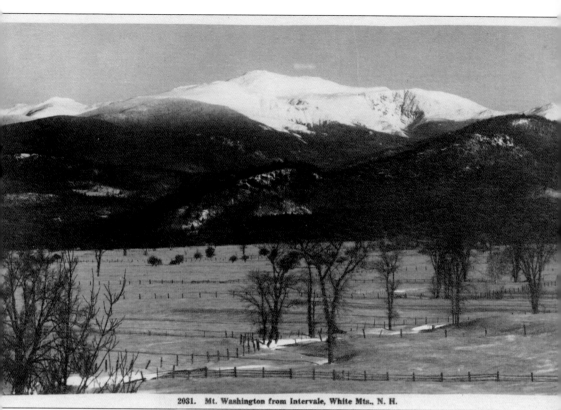

Mount Washington, from the intervale, is a very popular location to view the Presidential Range. The intervale is a long, narrow settlement, part of which is in the Bartlett Township and North Conway. The intervale's charm is in its surroundings, especially to the northwest (as seen in the picture) where the southern Presidential fills up the horizon. One of the finest views in the whole White Mountain Region is from the center of this village. From 1850 to 1890, this region was particularly favored by painters. Benjamin Champney (1871–1907), a New Hampshire–born painter, described the glorious era in *Sixty Years' Memories of Art and Artists*.

Seven

CRAWFORD NOTCH

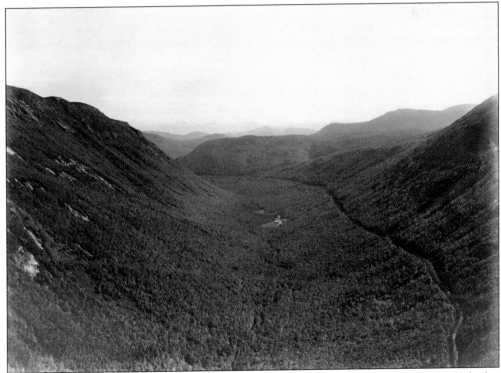

Looking south through Crawford Notch from the ledge of Mount Willard (elevation 2,850 feet) is a fantastic view of the road and the railway as they cling to the side of the mountain. According to Starr King in his *White Hills*, "The only way to appreciate the magnificence of the autumnal forest in New England is to observe it from the hills."

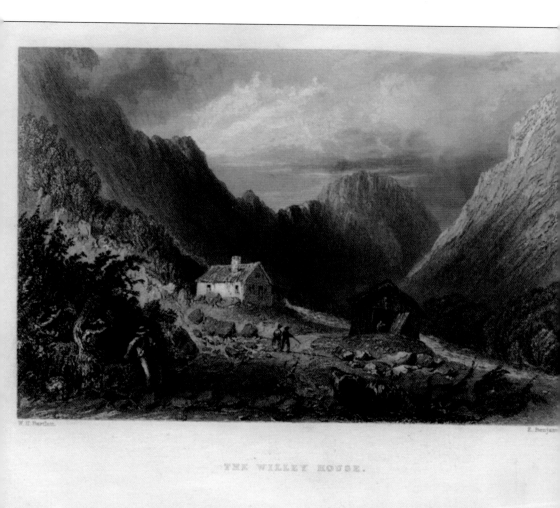

THE WILLEY HOUSE.

London Published for the Proprietors, by Geo Virtue 26 Ivy Lane, 1838.

This is a rendering of the Willey House, where on the night of August 29, 1826, the Willey family was swept to death by an avalanche. On the left-hand side of the road stood the simple little house of Samuel Willey and his family, located at the base of the high bluff that rises abruptly to a height of 2,000 feet. During the evening, a heavy rain began to fall, turning into a deluge shortly afterward. In the course of the night, a wild stream of loose rocks and debris came crashing down the mountainside. The next morning, those who survived found the intervale flooded. They began a feverish search for the Willey family. The little house was still standing, but there was no evidence of life about it except the family dog. The family Bible lay open on the table. The bodies of Mr. and Mrs. Willey, two of the children, and two of the farmhands were later found and buried in the intervale. The other three children were completely buried beneath the rocky debris. This picture was drawn by William H. Bartlett in 1838.

The Pearl Cascade is located on Mount Willard. From the Crawford Depot and the Mount Willard Trail ascends the Avalon Trail, which gradually climbs and soon crosses a brook. Just beyond this crossing, the path diverges left, passing Beecher and the Pearl Cascades.

The Silver Cascade on Mount Webster is one of the most admired and exquisite of the White Mountain's spectacle views. Its 1,000-foot course is made in long slides over smooth ledges and then by short and nearly perpendicular leaps over steeper rocks.

71

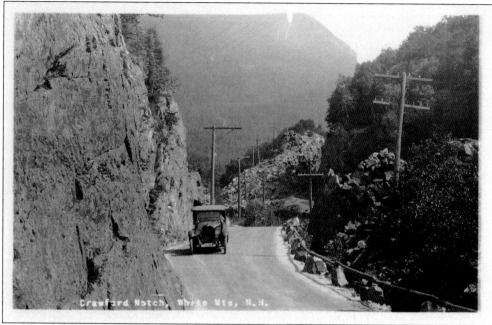

Crawford Notch, known as the Gate to the White Mountains, is a deep pass through the notch. It is approximately three miles in length, extending from the gate to the Willey House. The notch lies between Mount Willard in the west and Mounts Webster and Jackson in the east.

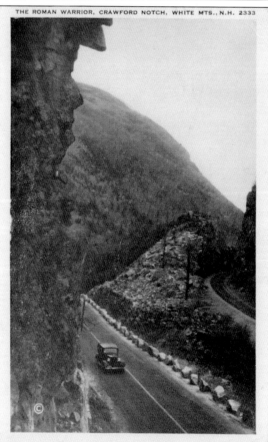

THE ROMAN WARRIOR, CRAWFORD NOTCH, WHITE MTS., N.H. 2333

At the gateway to the White Mountains are the roadway and the railroad tracks passing through the notch. The Roman Warrior in Crawford Notch stands guard at the gateway. The valley, from Lower Bartlett to the Willey House, is narrow, and mountain ranges rise boldly on either side, thus, forming an appropriate approach to the narrow gorge beyond.

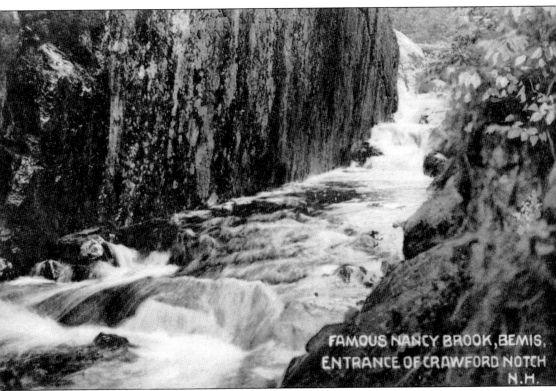

FAMOUS NANCY BROOK, BEMIS,
ENTRANCE OF CRAWFORD NOTCH
N.H.

Nancy Brook is known as the entrance of Crawford Notch. This mountain stream takes its rise from Nancy Pond, near the summit of Mount Nancy (altitude 3,180 feet), which a Harvard Latinist is said to have once christened Mount Amoris-gelu (the Frost of Love). Nancy's romance is vouched for by Ethan Allen Crawford in his biography, as told by his wife, Lucy. Nancy was said to have been the first woman to pass through the notch.

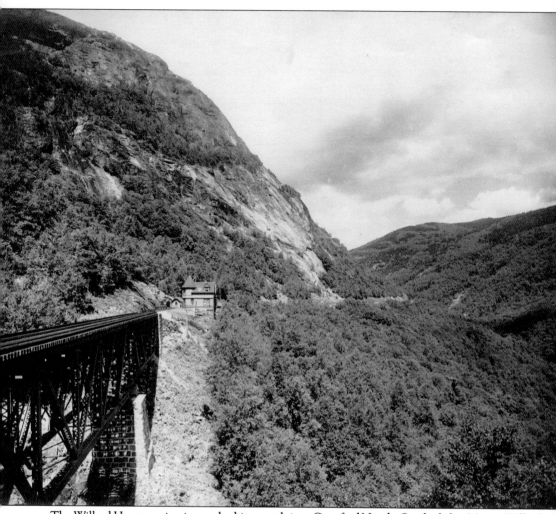

The Willard House station is seen looking north into Crawford Notch. On the left is Mount Willard with the Willey Brook Bridge and Frankenstein Cliff (elevation 2,150 feet). All are considered the heart of Crawford Notch. The notch is approximately 15 miles in length and two to four miles in breadth. Far down in the valley lies the site of the Willey House, as seen on page 70.

Eight

PINKHAM NOTCH

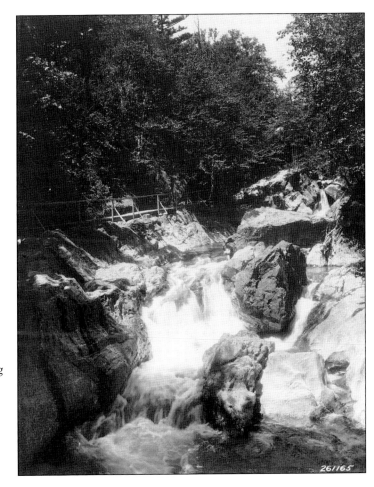

This section of the boardwalk was replaced with stonework in 1938 by the Civilian Conservation Corps (CCC). It is seen skirting the rapids above the brink of Glen Ellis Falls Stairs and Trail. These falls are located on the Ellis River at the base of Wildcat Mountain (elevation 4,422 feet).

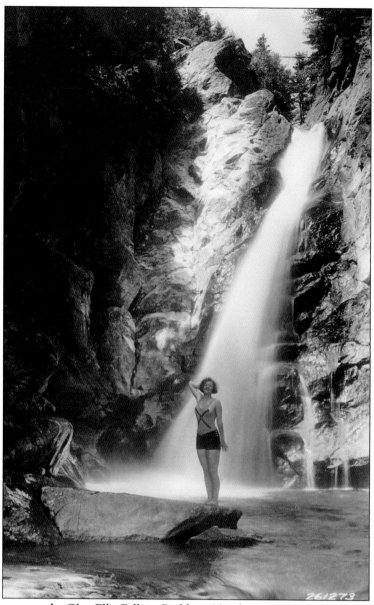

A bathing beauty at the Glen Ellis Falls in Pinkham Notch is seen posing near the crystal clear waters located about four miles south of the former Glen House on North Conway Road (Route 16). As seen in this 1931 photograph, the falls descend through worn walls of granite for over 70 feet and are considered to be the finest in the White Mountains. The falls are associated with an Indian legend of the daughter of an Indian chief who ruled over this territory. She had been secretly wooed and won by a young brave from a neighboring tribe, however, her father had promised her to one of his own warriors. When the young stranger arrived at the village to claim his bride, the old chief could not refuse him outright and said that the suitors must settle their dispute before the council by bow and arrow. The one who came the nearest to the center of the target would win his daughter. To the maiden's grief, her lover lost the contest. Before the other suitor realized what was happening, the couple ran into the woods to the edge of the falls and flung themselves into the rushing water.

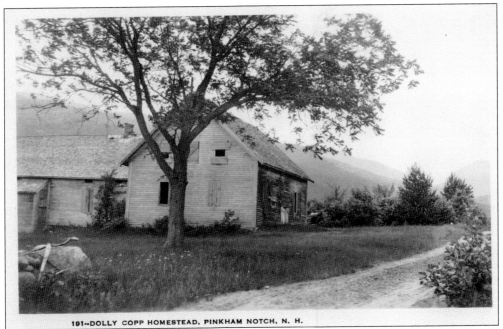

191—DOLLY COPP HOMESTEAD, PINKHAM NOTCH, N. H.

In 1915, the Dolly Copp Homestead in Pinkham Notch was considered a noted historic landmark. Dolly Copp, an early pioneer and character of the region, lived on the old Copp farm, which has long since been abandoned. Her home was replaced by a long, low frame house—the foundation of which may be traced to this location.

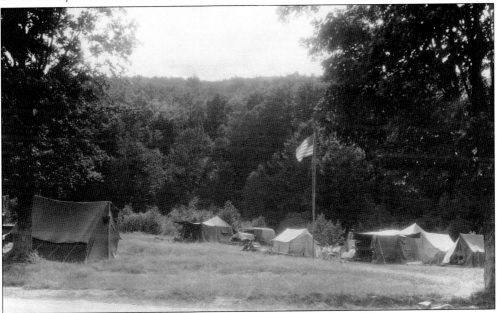

Dolly Copp is one of the largest campgrounds in the entire national forest system, regularly hosting more than 1,000 people per night. The campground is located just north of the Glen House on Route 16. East from the camp, across the highway on a marked trail, are the upper ledges of Imp Mountain (elevation 3,730 feet). Here is a quiet corner of the forest campground seen on an August afternoon in 1931.

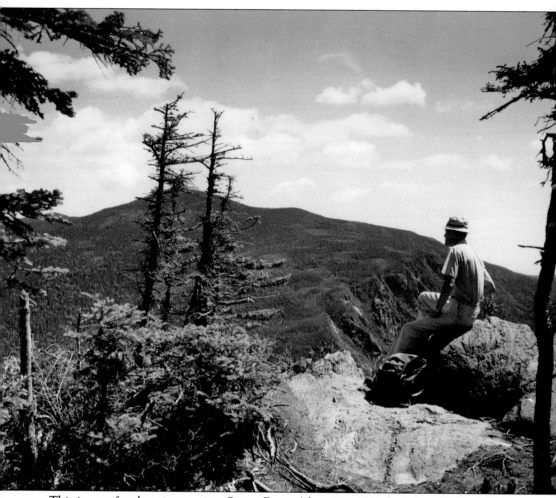

This is a perfect location to view Carter Dome (elevation 4,832 feet) from Wildcat Mountain. It is interesting to note that the name Mount Carter is applied only to the peaks nearly behind the Glen House. Carter Dome once bore a fire tower on the scrub-fringed summit. There are excellent views in most directions from the open areas in the vicinity of the summit. Several summits are included in the Carter Mountains. South Carter Mountain (elevation 4,430 feet) is wooded with no view. The Middle Carter Mountain (elevation 4,610 feet) is wooded, but there are good views along its ridge trails. The North Carter (elevation 4,530 feet) has good views from the summit and ledges along the ridges north and south of the summit.

Nine

EARLY-20TH-CENTURY LOGGING IN THE WHITE MOUNTAINS

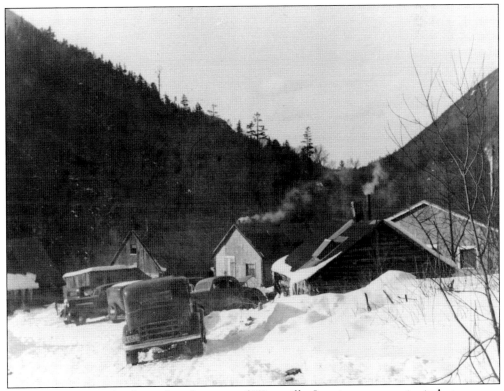

Logging Camp No. 5 is located in the town of Waterville. Logging was a major industry across the breadth of the White Mountains. The drama of logging unfolded between the years of 1875 and 1915; it was an era dominated by ambitious lumber kings. Today, land management of the White Mountain National Forest focuses on timber harvesting, water, wildlife, and recreation.

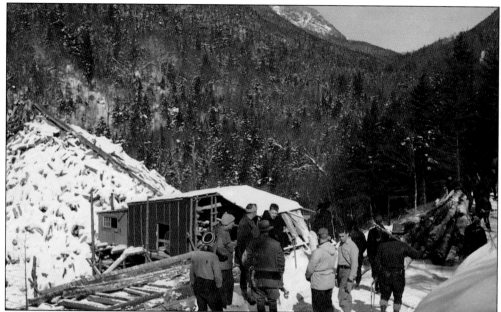

The Cutting Mill at Camp No. 5 is a typical portable mill in Waterville. This camp, located at the junction of Mad River and Flume Brook on Skid Road, was in full operation on March 11, 1937. Harold J. Piper is seen discharging logs on the conveyor to the pile. When the railroads arrived, loggers came to the mountain slopes of Waterville Valley, which resulted in changes to the landscape of New Hampshire.

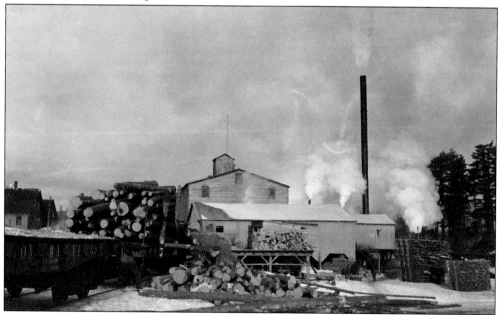

The sawmill of the Whitefield Lumber Company is seen operating on national forest lumber in Whitefield during the 1920s. Large-scale logging operations commenced during the 1880s under companies and landholders, such as the Whitefield Lumber Company, the Publishers Paper Company, the International Paper Company, the White Mountain Paper Company, and eventually, the Parker Young Company.

This is a view of Berlin from Kate's Hill, with the Brown Paper Mill in the center of the picture. It was a century ago that the Brown Paper Company was a dominant presence in the Great North Woods and in an active social and economic landscape. The Adroscoggin River runs alongside the mill. In the distance is the Mahoosuc Range.

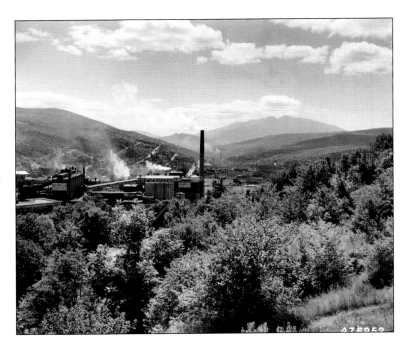

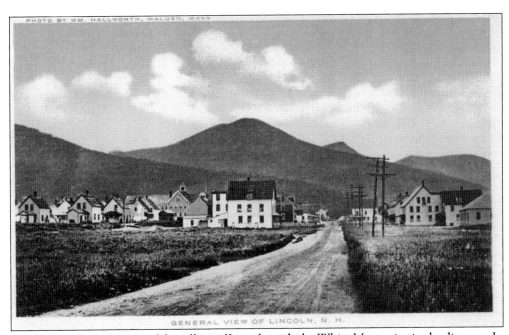

This is an early-1900s view of the village of Lincoln with the White Mountains in the distance. In 1892, James E. Henry and Sons established a logging industry in Lincoln. On August 30, 1917, the Henry company sold the East Branch & Lincoln Railroad, as well as 100,000 acres of woodland, 150 homes, three mills, and the Livermore Falls water rights to the Parker-Young Company. The sawmill era came to an end, with the last log being sawed in June 1960.

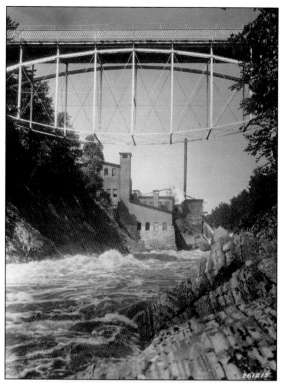

During the 1930s, the ground wood pulp plant of the Parker-Young Company at Livermore Falls on the Pemigewasset River was located three miles above Plymouth. According to the Chittenden Report of 1904, "During the years between 1890 and 1900, the growth of the paper and wood pulp industry in New Hampshire, the value of its product had multiplied nearly six times."

The loggers are seen rolling logs from the sled at the mill in Passaconaway. During this period (1938), the logging industry depended on the waterways of the Pemigewasset and Mad Rivers. By the 20th century, the dramatic process of conveying lumber logs and pulpwood from the northern New Hampshire forests to a manufacturing center was achieved by driving them down the major rivers.

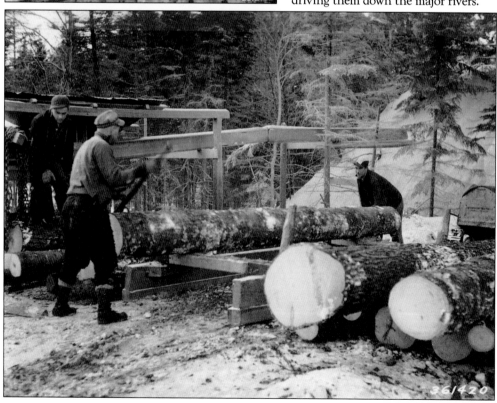

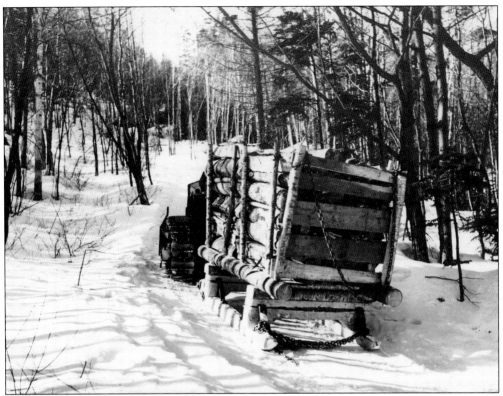

In 1930, this F.S. tractor was seen hauling firewood to the US Forest Service warming shelter in Tuckerman Ravine. It was a time that left deep scars visible for many years to come. Today, the back country shows the telltale signs of this dramatic period: signs of an old logging camp and forest fire lines in the Rocky Branch, the Kilkenny, and the Pemigewasset areas.

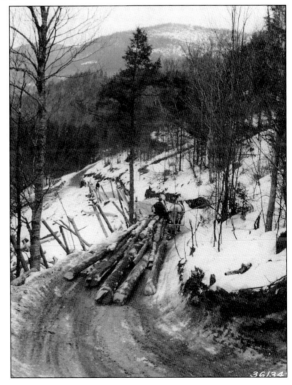

A team of two horses is seen dragging pulpwood from the forest on the old lumber road in Waterville Valley in 1938. "Starting about 1850," continues the Waterville Unit Plan, "as the farms were being abandoned for the richer farmland on the Midwest, forest lands in the valley were bought up in very large tracts by land companies and trusts such as the Merrimack River Lumber Company and the New Hampshire Land Company. Extensive logging operations began about 1880 and continued for fifty years."

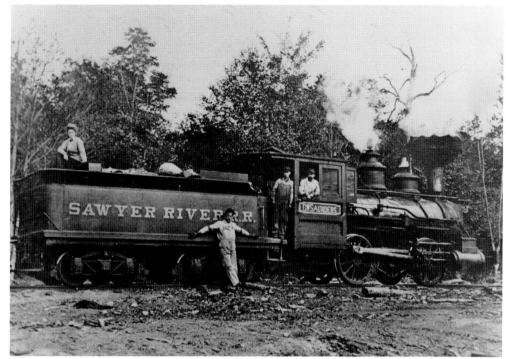

This is the Sawyer River Railroad Company locomotive, which operated from 1876 to 1927. When the railroads arrived in the 1840s, they opened up a vast new territory for lumbering, primarily in the wilderness of the Pemigewasset Valley. According to the White Mountain National Forest's Waterville Unit Plan (1978), "There were more lumbermen than agriculturists, and many farmer had their own sawmills, relying heavily on logging and lumbering to survive on their rocky lands."

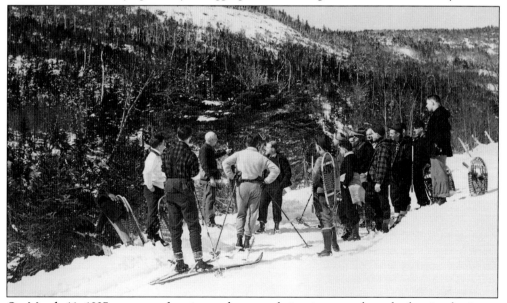

On March 11, 1937, a group of senior students are being instructed on the logging business. The scene is from the logging road one mile above Camp No. 5 near the cutters' camp in Waterville Valley.

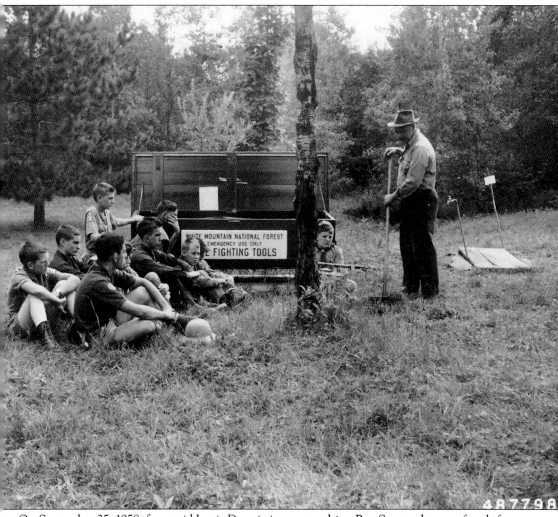

On September 25, 1958, forest aid Louis Derosia is seen teaching Boy Scouts the use of tools for fighting forest fires at the Ammonoosuc Ranger District. On August 27, 1907, the *Boston Post* ran an editorial that stated in part, "In the once virgin and beautiful White Mountain region it is happening as predicted. Following the lumbermen comes the fire, and it is the end of forest beauty for not less than a generation and perhaps forever."

On January 10, 1903, the New Hampshire legislature passed a bill favoring the proposal to establish a White Mountain reserve and giving the state's consent to the acquisition by purchase, gift, or condemnation of lands that the federal government might be needed for the purpose. It was Congressman John Weeks who rewrote the National Forest Bill, which combined forest preservation with watershed protection and fire control. In February 1911, the 61st Congress passed a bill known as the Weeks Act for the protection of the White Mountain National Forest. The bill became law when Pres. William Taft signed it on March 1, 1911.

Ten

RECREATION IN THE WHITE MOUNTAIN NATIONAL FOREST

Due to the natural beauty of the White Mountains and their proximity to major metropolitan areas, the 1,200 miles (1,900 kilometers) of hiking trails, camping sites, scenic roads, hunting and trapping, fishing and other water activities, wildlife viewing, and several ski area and historical sites, the White Mountain National Forest has become a magnet for visitors to New Hampshire.

In August 1931, Boy Scouts are seen packing in supplies on the Valley Way Trail for an adventurous hiking project into the mountains. The camping program for the Scouts includes a wide range of outdoor activities: overnight hikes, short-term or weekend camps, winter camps, and truck tours, all of which add variety to outdoor living.

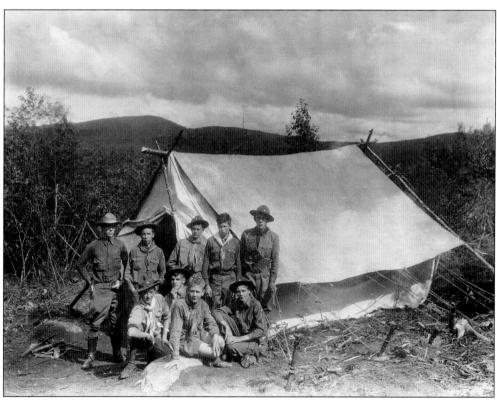

District ranger Truman E. Hale (back row, left) and his crew of Boy Scouts are preparing for a project to improve the Valley Way Trail over the Presidential Range during the 1931 hiking season. The success of each camp conducted by the Boy Scouts is determined by the extent to which it achieves the main objective of scouting in character building and citizenship training.

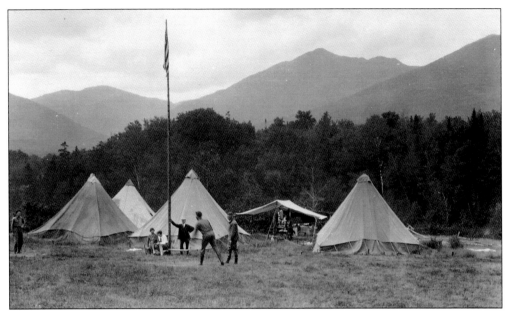

The boys are attracted by the lure of outdoor life and the challenge for wholesome adventure at Camp Makualla along the Glen Road in the Presidential Range. The White Mountains are the Alps of New England, with all the outdoor pastimes and joys that the term implies and much of the rugged grandeur, which the scouts enjoy in their outdoor adventures.

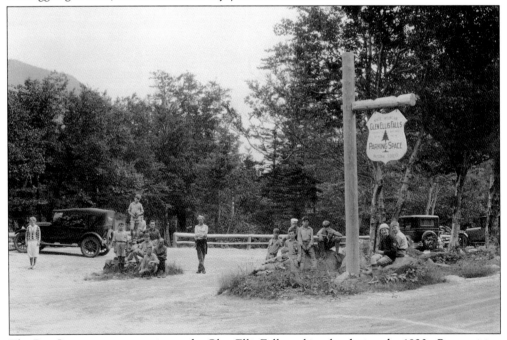

The Boy Scouts are seen resting at the Glen Ellis Falls parking lot during the 1920s. Recognizing a time for rest and reflection is an important virtue for Scouts. These falls are considered some of the most beautiful in the state and are within easy access from the highway. Right on a signal path near the parking lot are the falls, 600 yards away in a tract of 29 acres owned by the Appalachian Mountain Club (AMC).

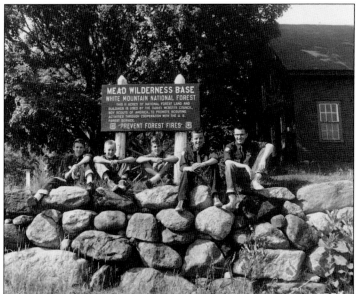

The local Boy Scouts are relaxing around the Mead Base sign near the entrance to Sandwich Notch. Mead Base is located on a side road off Sandwich Notch. This historic, 19th-century farmhouse is operated under a special-use permit by the Squam Lakes Association as the Mead Conservation Center. The grounds are open to the public, but there is no public access to the house.

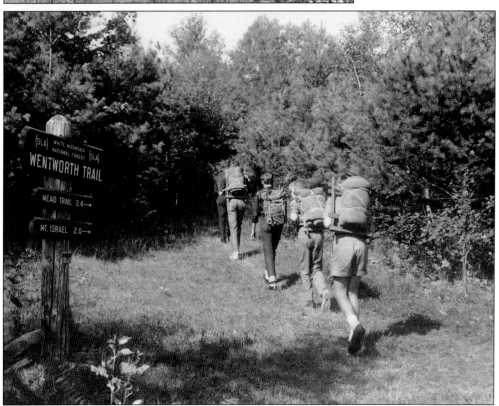

Boy Scouts have assembled at the entrance of Wentworth Trail in Sandwich. This trail ascends Mount Israel (elevation 2,630 feet) from the Mead Base. The trail follows an old cart path to the summit of the mountain through an opening in a stone wall located above the camp. From the open ledges of the trail, there are fine views of the Squam and Winnipesaukee Lakes. This photograph was taken in August 1958.

Here is the Jim Liberty High Country Cabin, a US Forest Service camp equipped with all the modern necessities. This hut is located on Mount Chocorua east of the Sandwich Range Wilderness.

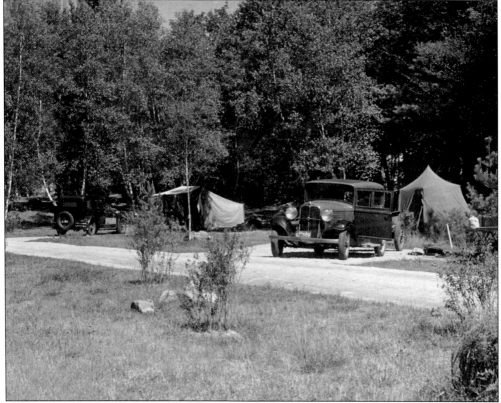

During the 1920s, a typical campsite in the White Ledge Forest Camp was seen near the eastern base of Mount Chocorua, one of the older White Mountain National Forest camps. As time progressed, campgrounds sprouted up, and campers fell in love with the outdoors.

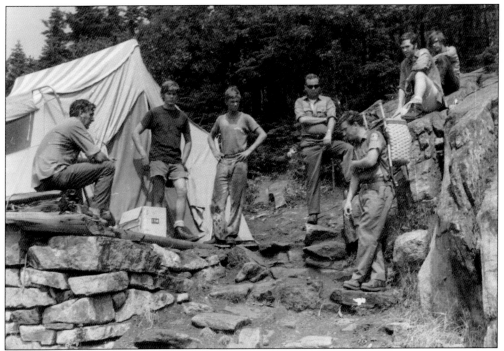

This is known as the Liberty Spring caretaker site. From left to right are Bob MacHaffie, Bob Tyrrel, Russ Rogler, and Tom Deans; the other men on the right are unidentified. The Liberty Spring campsite, a fine facility, is located near a mountain spring on the Liberty Spring Trail below the junction of the Franconia Ridge Trail.

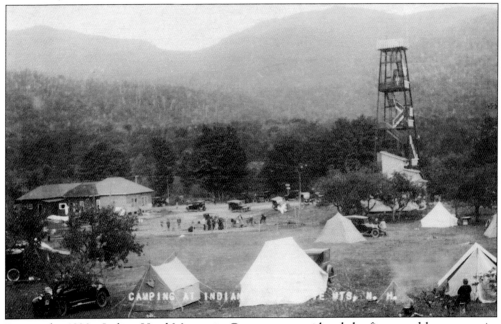

During the 1930s, Indian Head Mountain Camp was considered the finest and largest tourist camp in the state. Today, Indian Head is a very popular year-round resort drawing thousands of visitors to the White Mountains.

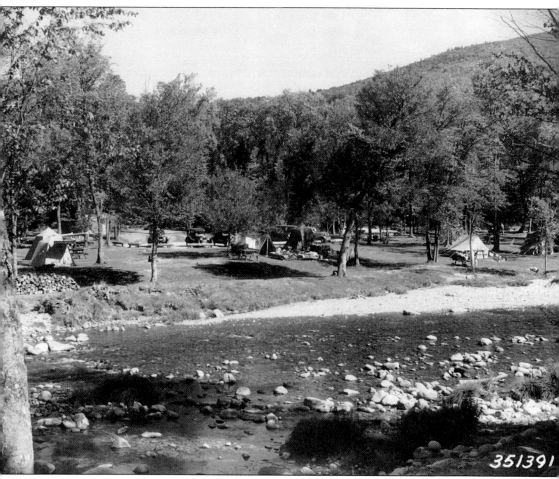

This popular campsite, shown in July 1936, is known as the Zealand Forest Camp and located next to the Ammonoosuc River. From this campground on the Zealand Road and Trail are the Twin Mountain Range and the Zealand Falls Hut. This hut is a trail junction for paths leading to Crawford Notch and Pemigewasset East Branch.

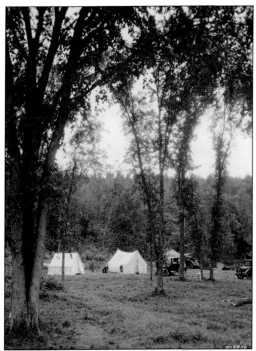

In 1920, campers at Zealand campground are settling down for a country vacation. From this campground can be seen the Zealand Notch, Twin Range, and Zealand Falls.

A favorite spot for picnicking is at the Zealand Picnic Area on Route US 302 near Twin Mountains by the beautiful Ammonoosuc Valley. Here visitors may view the following mountains: North Twin Mountain (elevation 4,769 feet), Mount Garfield (elevation 4,488 feet), and Mount Lafayette (elevation 5,249 feet). Down in the valley are Mounts Agassiz (elevation 2,378 feet) and Cleveland (elevation 2,397 feet).

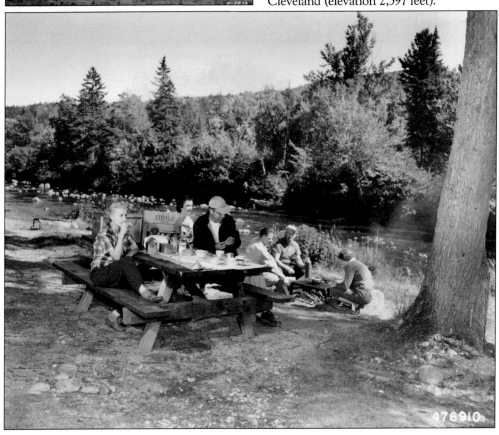

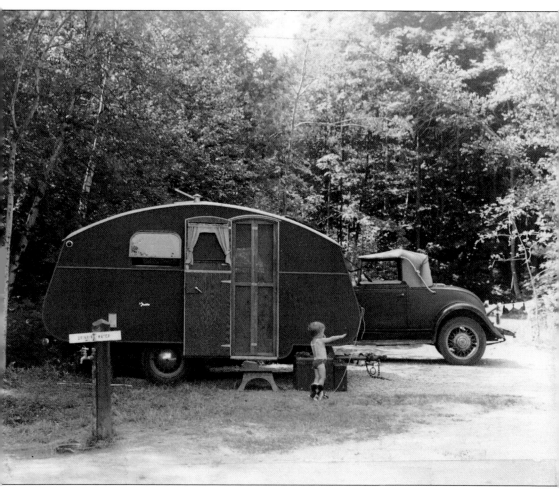

The White Ledge Forest Camp, located near the eastern base of Mount Chocorua, is one of the older White Mountain National Forest camps. Trailer camping is very popular here. Organized camping in the White Mountains dates back to the 1860s, however, recreational camping did not take root until the 1920s. The advent of the automobile and the expansion of the tourist trade began to allow people access to a world beyond their neighborhood. Those traveling with trailers and other motor homes, as seen in this photograph from 1937, became known as "tin can tourists."

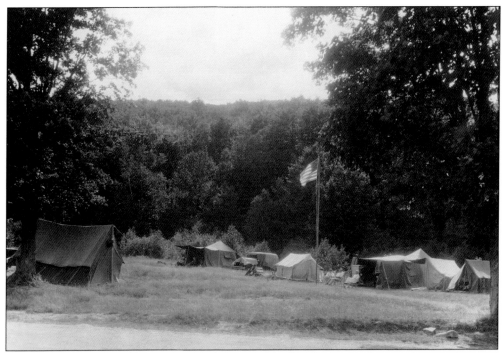

A quiet corner of the Dolly Copp Forest Camp neighborhood is pictured on an August afternoon in 1931. The US Forest Service oversees the campground managers, who operate Dolly Copp under a special-use permit with the White Mountain National Forest.

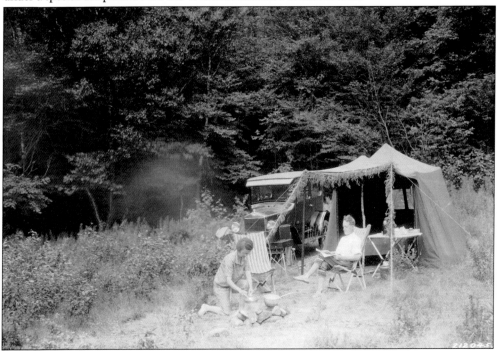

A couple of vacationers are seen camping along the Peabody River at Dolly Copp Camp during the 1920s. The camp was named for an early settler and character of the region.

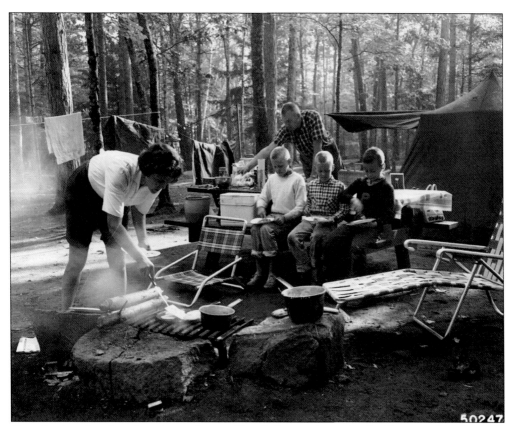

Camping is a time for relaxation and a good bowl of soup. An active family starts their day with a hearty breakfast of pancakes at the Dugway campground. Left on the Dugway Road in Conway is a route through the White Mountain National Forest with fine views of the surrounding mountains and notable Mount Chocorua.

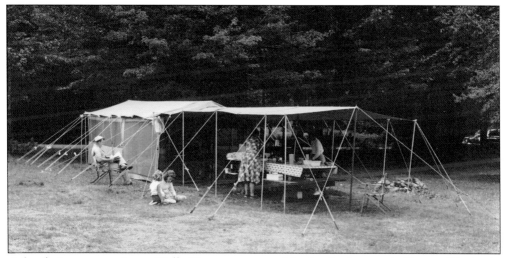

A family is tent camping at Dolly Copp campground in the Androscoggin Ranger District in Gorham in August 1958. The campground is popular because it is secluded but offers the best view of the Carter Range, which dominates the east.

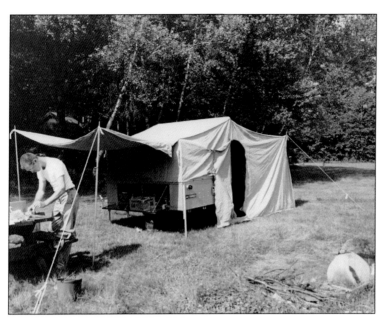

A tent trailer unit is seen at the Waterville campground, a secluded spot located on the Waterville Valley Road and frequented by those interested in fishing and hiking. This was a popular scene during the 1960s.

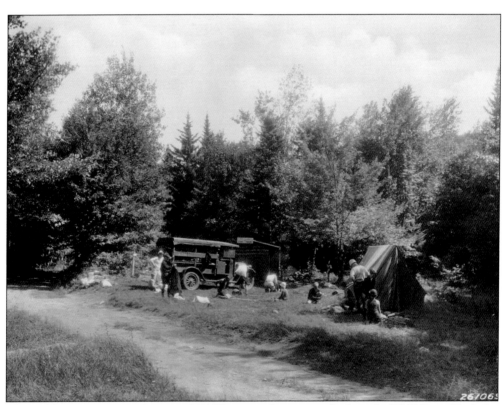

The Wild River Camp on the upper Wild River is often approached via the Wild River Trail, the Moriah Brook Trail Bridge, or the High-Water Trail.

Camping is fun for the whole family in the beautiful White Mountains. The 23 developed campgrounds in the White Mountain National Forest range in size from 7 to 176 campsites. Most campgrounds offer a paved roadway with gravel campsites, toilets, hand pumps for water, and a bear-proof trash dumpster.

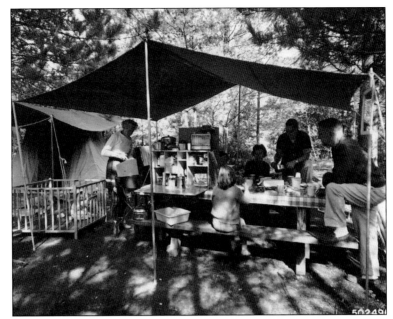

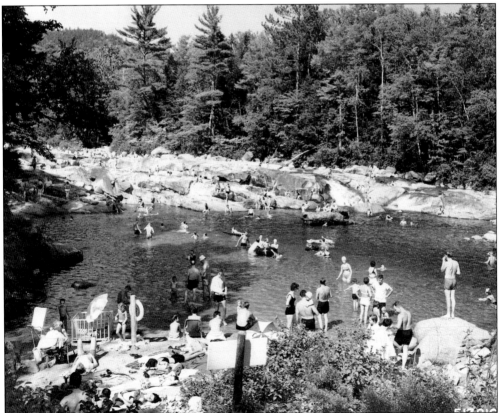

Swimmers at Lower Falls are enjoying a summer afternoon of bathing and relaxation. The Lower Falls are located in the Swift River off the Kancamagus Highway. This scene was taken in August 1965; it is still a popular spot for swimmers.

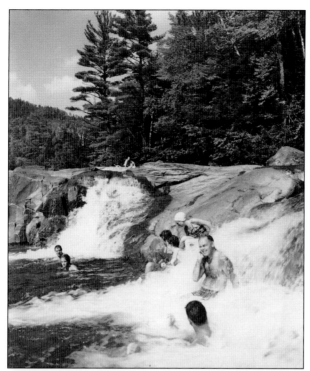

Summer visitors escape the heat to enjoy a refreshing dip in the sparkling cold water of Swift River at the Lower Falls. With its rock walls glistening from the action of the turbulent waters, the Lower Falls is a natural place for swimming.

Many summer sunbathers are seen enjoying a moment of relaxation in Swift River. The Swift River Road is a scenic route that crosses and recrosses the well-named river. Lined by polished boulders, the stream has many rapids and falls of unusual beauty, among them are the impressive Lower and Upper Falls (Rocky Gorge). This 1950s photograph is also typical of the scene today.

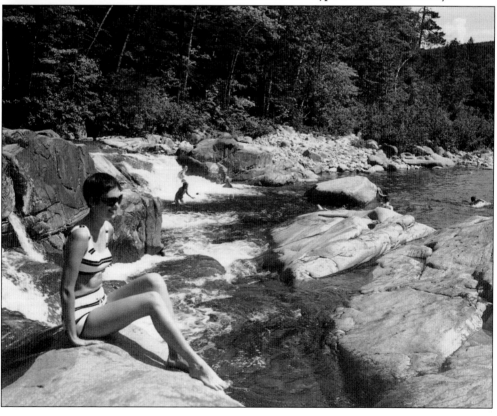

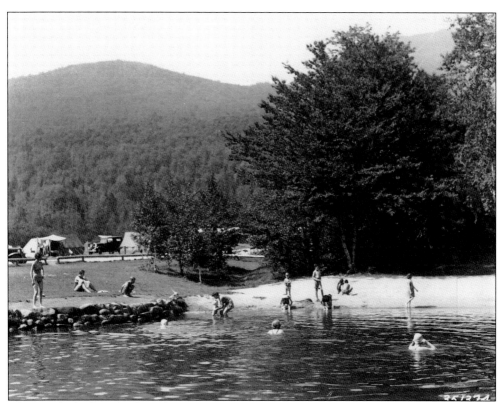

The popular bathing pool and beach at Dolly Copp Forest Camp in Gorham was considered the most popular of all New Hampshire's many camps during the 1930s. This pool no longer exists.

The Russell-Colbath House on the Kancamagus Highway in Albany is a 19th-century farmhouse with period furnishings. The dwelling is operated as a historic house museum with an on-site historical interpreter. Visitors can learn about the history of the Passaconaway Valley, the families who lived in the house, and view artifacts uncovered in recent archaeological excavations.

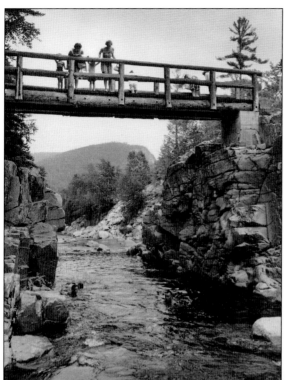

Air-conditioned by nature, this spot on New Hampshire's unique Kancamagus through-the-wilderness highway to the White Mountains certainly looks cool and welcoming. The highway extends some 35 miles between Lincoln and Conway within the southern boundaries of the White Mountain National Forest and is totally noncommercial. This highway ranks among the top dozen greatest scenic attractions in New Hampshire.

Casting for trout in one of the many rivers in the wilderness is very popular with anglers. Miles of rivers and mountain streams are abundant throughout the national forest. There are as many as 12,000 miles of rivers and streams and 975 lakes and ponds in the state. Fishing is very good, with salmon being stocked and taken from early spring through the summer months.

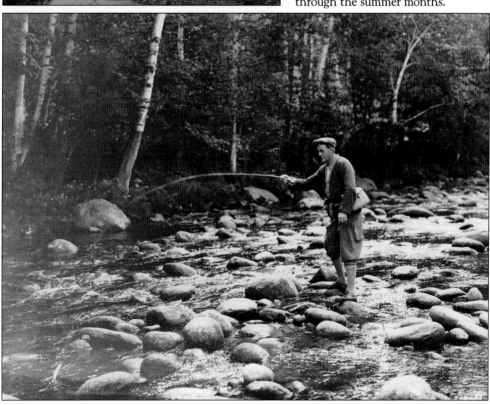

Two unidentified Fish and Game officers are netting fish in Sky Pond. The pond is 13 acres of pristine water in New Hampton. Brook trout are plentiful. The clear, cold water in the mountains is ideal for fishing, and trout are abundant.

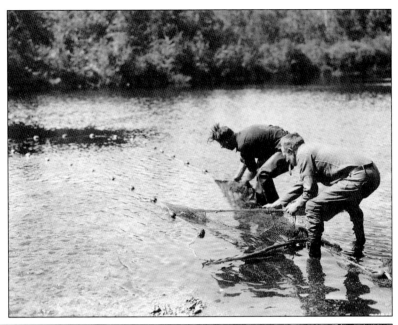

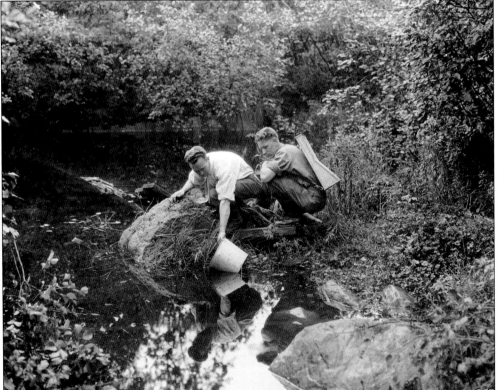

Two unidentified Fish and Game officials are seen stocking the local streams. The New Hampshire Fish and Game Department operates six fish hatcheries that contribute significantly to the fishing pleasure of resident and nonresident anglers. The hatcheries are year-round; the fish and wildlife centers are only open May through mid-October.

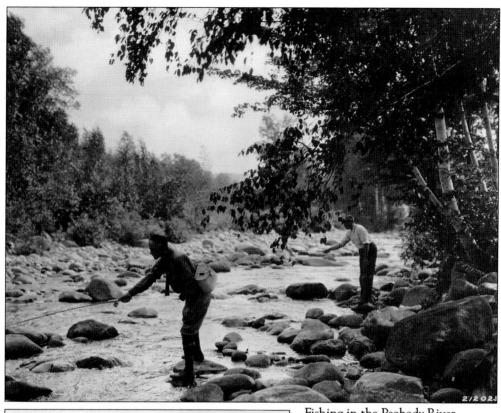

Fishing in the Peabody River at the Dolly Copp campground is said to be excellent. Brook trout, rainbow trout, and brown trout are plentiful. With many lakes, rivers, and waterfalls, the New Hampshire mountains have long been an attraction for thousands of fishermen.

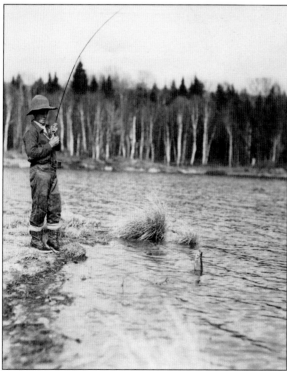

Richard Bailey (12 years old) of Woodsville is seen landing a good one at Long Pond near the dam in Breton on May 9, 1937. Fishing is very good in New Hampshire, with bass, pickerel, whitefish, shad, and perch all being taken in their proper season.

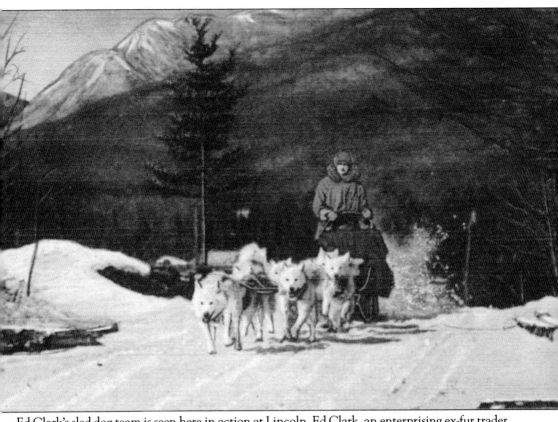

Ed Clark's sled dog team is seen here in action at Lincoln. Ed Clark, an enterprising ex-fur trader, maintained the celebrated Eskimo Sled Dog Ranch where purebred American Eskimo dogs could be seen. Today, it is the site of Clark's Trading Post, where exhibits of sled dogs may be seen.

April 3, 1932, was Florence Clark's third and finally successful attempt to drive a team of five American Eskimo sled dogs to the top of the mountain. She was the first woman to drive a sled dog team to the summit of Mount Washington and back. She is pictured here with Clarkso, her female lead dog.

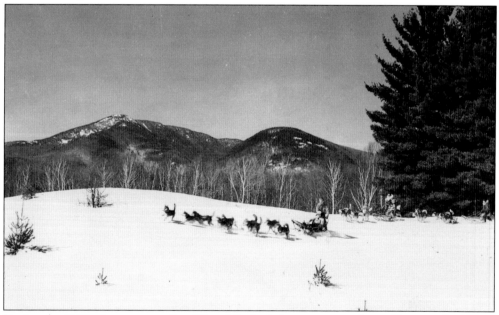

During the 1930 winter season, Eva (Short) Seeley's dog team was pictured here in the White Mountain National Forest foothill in Wonalancet (Tamworth), with Mount Washington in the background. It was in Wonalancet that the famous Chinook Trail and Kennels were located. Eva Seeley was instrumental in the establishment of the Alaskan Malamute breed in the lower 48 states and key in winning the American Kennel Club's recognition of the dog in 1930.

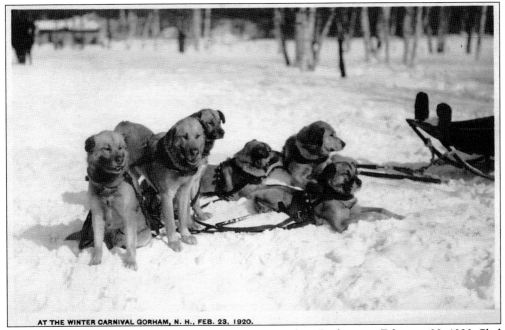

AT THE WINTER CARNIVAL GORHAM, N. H., FEB. 23, 1920.

This sled dog team is seen resting at the winter carnival in Gorham on February 23, 1920. Sled dog racing in New Hampshire became very popular. The World Championship Sled Dog Derby was established in Laconia in 1929. These races continue today and are sponsored by the Lakes Region Sled Dog Club.

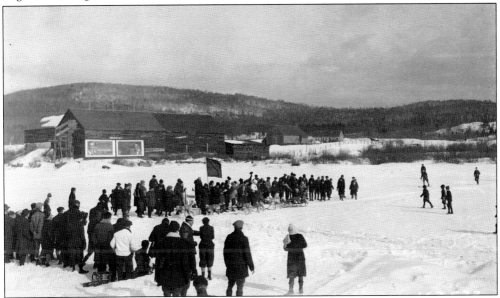

Arthur T. Walden of Wonalancet is seen racing at the international 120-mile dog race, crossing the finish line on the Androscoggin River in Berlin in February 1922. Walden trained and raced his dog (named Chinook) in both the Wonalancet and Chinook kennels, which became a feature attraction throughout New England. At the kennels was Adm. Richard Byrd's own team of seven dogs, all born in Antarctica. Walden accompanied Byrd on the Admiral Byrd Expedition to Antarctica in 1928.

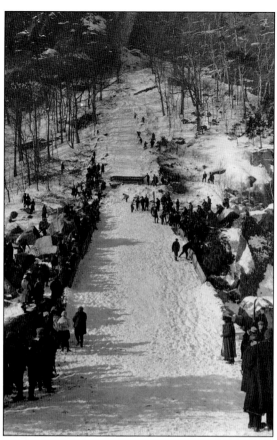

The White Mountain National Forest ski jumping contest in North Conway was very popular during the early 1900s, especially in North Conway.

This was a pulpwood-sawing contest at the winter carnival in Berlin during the 1920s. Berlin was a large lumbering community in the Great North Woods, with the Brown Paper Mill as its chief reason why. These winter carnivals were very popular in the North Country of New Hampshire.

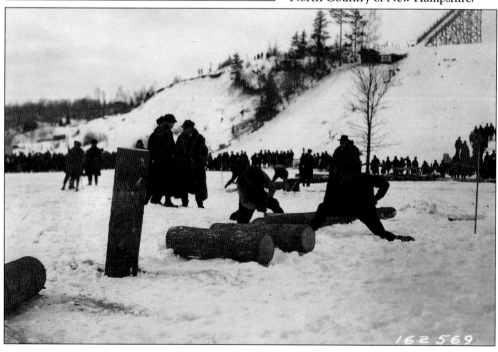

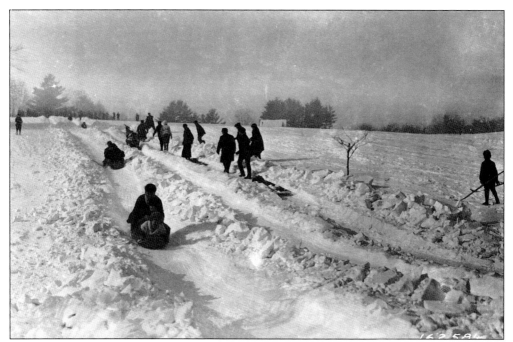

Toboggan sliding was a popular activity at the winter carnival in Conway. During the 1920s through the 1950s, winter carnivals were held in most communities throughout the North Country of the state.

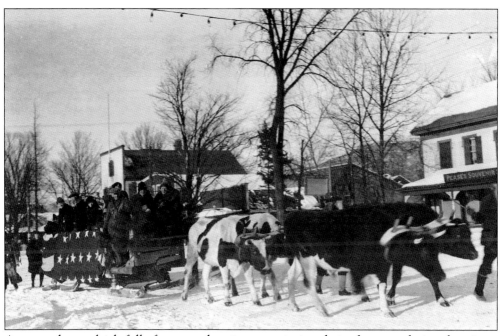

An oxen-drawn sleigh full of merrymakers is seen enjoying their afternoon during the winter carnival in North Conway in February 1922. Winter sports for young people during the early 1900s consisted of skating, sleigh riding, coasting parties, and snowball fights.

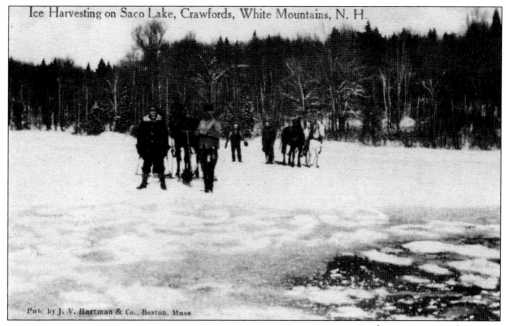

Ice Harvesting on Saco Lake, Crawfords, White Mountains, N. H.

Pub. by J. V. Hartman & Co., Boston, Mass

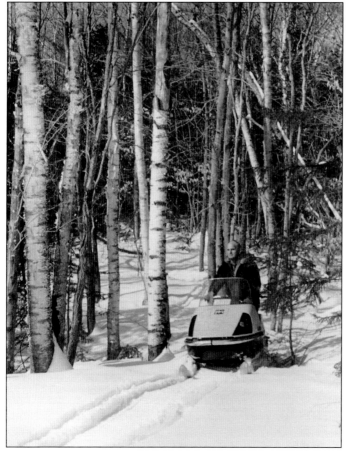

Ice harvesting on the Saco Lake in Crawford Notch was considered big business after the January thaw during the early 1900s. In the spring and summer months, ice trucks were loaded and bound for the cities to fill the family icebox.

A solo snowmobile adventurer is enjoying a ride through the White Mountain National Forest. Over 365 miles of snowmobile trails are maintained in the national forest by the cooperative efforts of snowmobile clubs, the US Forest Service, and the states of Maine and New Hampshire. Snowmobile drivers consider the trail systems to be one of the best in the United States.

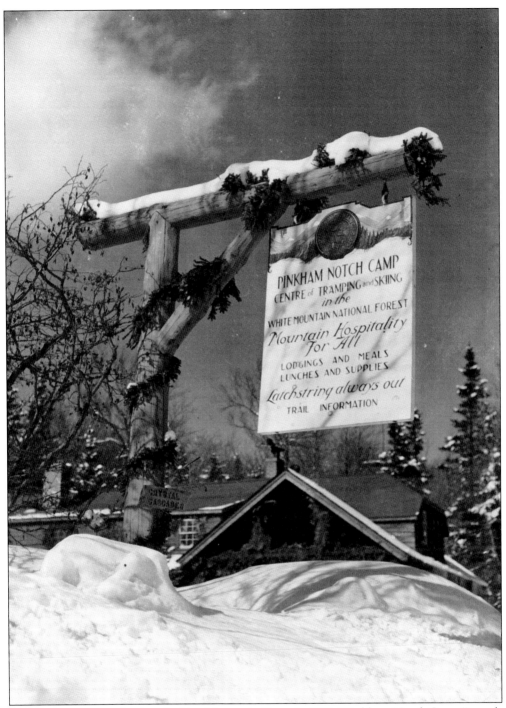

The entrance sign at the Appalachian Mountain Camp in 1938, "Pinkham Notch Camp," stands as a warm welcome to the notch. A road was soon opened by the proprietors of the land in upper Cohos in 1774, as well as another through the eastern pass. It was named for Joseph Pinkham, who settled in the present town of Jackson in 1790.

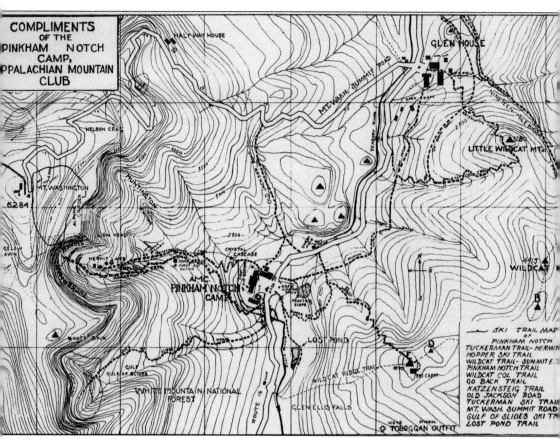

Shown here is a map of the Pinkham Notch Camp for the Appalachian Mountain Club. The camp, located at the trailhead to Tuckerman Ravine, is a leading ski center in the White Mountains.

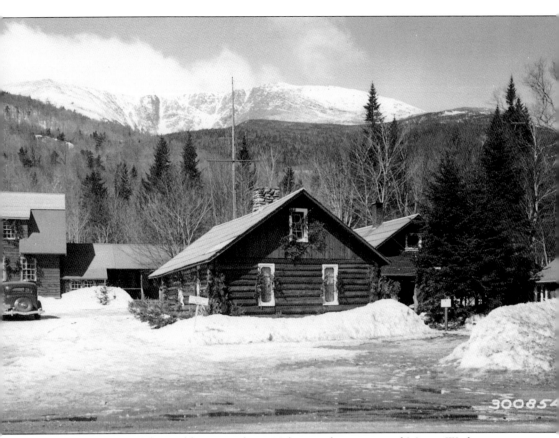

This is a winter scene of the Pinkham Notch AMC huts with snowcapped Mount Washington in the background. To promote winter sports, the White Mountain National Forest officials have built new trails and adapted old trails for ski use. The Pinkham Notch Visitor Center is considered a unique mountain sport facility in the heart of the White Mountain National Forest. This facility, originally built in 1920 and enlarged since then, is located on New Hampshire Route 16 in Pinkham Notch, about 20 miles north of Conway and 11 miles south of Gorham.

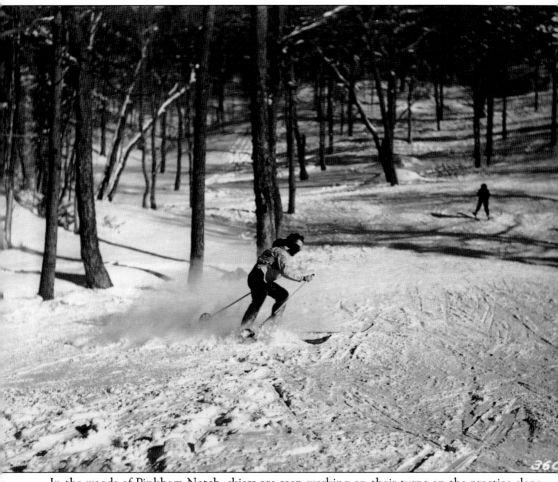

In the woods of Pinkham Notch, skiers are seen working on their turns on the practice slope during the 1930s. The Pinkham Notch Camp is considered the leading ski center in the White Mountains. In Tuckerman Ravine, this exhilarating sport frequently lasts into May and June.

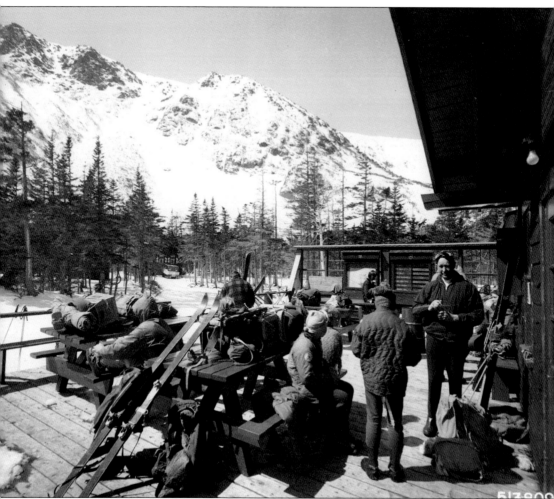

From the deck of the Tuckerman Ravine shelter, excellent views of Hillman's Highway and the south portion of the bowl are visible. Snow rangers' quarters and weasels are seen in the background. It was not until 1911 or 1912 that men entered the bowl on skis. Many ski resorts operate in the national forest, and visitors are encouraged to use the slopes. There are numerous areas in the White Mountains that attract thousands of skiers and visitors alike.

Skiers are seen on the John Sherburne Trail near the entrance to Tuckerman Ravine. This is the best way into the bowl and head wall; it is a climb of about three hours. The trail begins near the Maine and New Hampshire border, passes between the Shelburne-Moriah Mountains (elevation 4,049 feet) and Howe Peak, and continues a descent to Wild River. This trail, named for John Sherburne Jr., whose efforts contributed to its establishment, leaves the south end of the parking lot at Pinkham Notch Visitors Center at the same point as the Gulf of Slides Ski School.

These spring skiers are at the head wall of Tuckerman Ravine. The skiers have paused on the John Sherburne Trail near the entrance to Tuckerman Ravine (famous alpine snow bowl), where skiing usually lasts throughout the spring months. In the bowl of the ravine, the skiers are faced with a 900-foot precipitous wall. This head wall is not the place for beginners or those who do not like to climb.

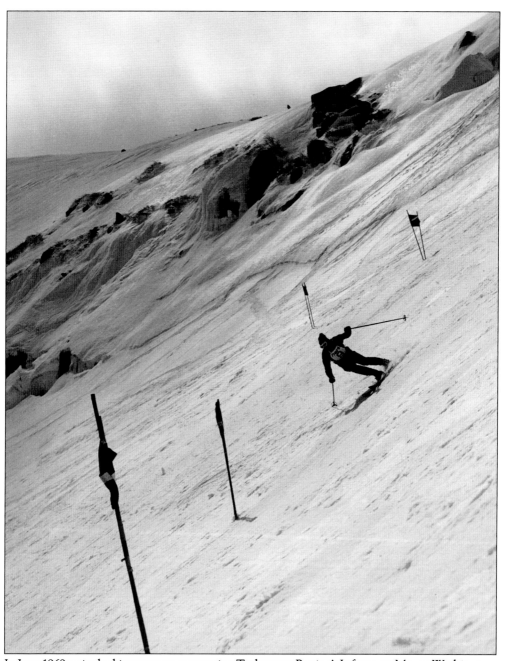

In June 1969, a single skier was seen attempting Tuckerman Ravine's Inferno on Mount Washington. This arch is one of the most striking spectacles in the White Mountains. This phenomenon is formed by deposited snow blown over the edge of the rocky plateau, forming the eastern wall of the ravine.

These hardy skiers are walking on the trail toward Tuckerman Ravine. Notice the campsite on the right in the shade of the pine trees. Tuckerman Ravine is known as a mountain colosseum. It is about a mile in length, half a mile wide, 1,000 feet deep, and one of the great glacial cirques (the bowl-shaped basins and the deep, round-bottomed valleys with semicircular head walls dissect the Presidential Range and, for the most part, reduce it to a winding ridge).

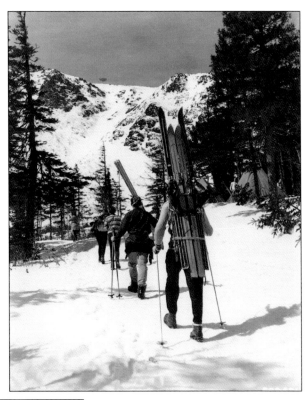

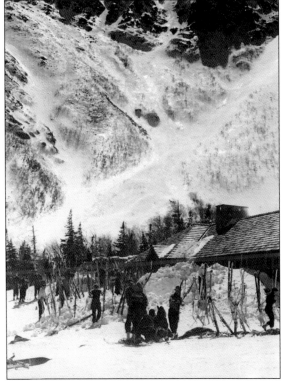

Ski fever at Tuckerman Ravine has become very popular for groups like the Dartmouth Outing Club. The club not only promoted skiing to their members but also helped to establish ski routes that are used today. Here, the skiers assemble in front of the US Forest Service Shelter at Tuckerman Ravine as they prepare to ski. Winter recreation received its first real impetus through the organization of the Dartmouth Outing Club in 1909.

These skiers are climbing Tuckerman Trail to Tuckerman Ravine, which is considered the center of late spring skiing in New England. This photograph from April 18, 1937, was taken near Crystal Cascade on the Cutler River, which rises in Tuckerman Ravine. The ravine area, as well as the John Sherburne Trail, are frequently patrolled by US Forest Service rangers and the Mount Washington Volunteer Ski Patrol. The trails afford an easy ascent route on foot since it is normally well packed.

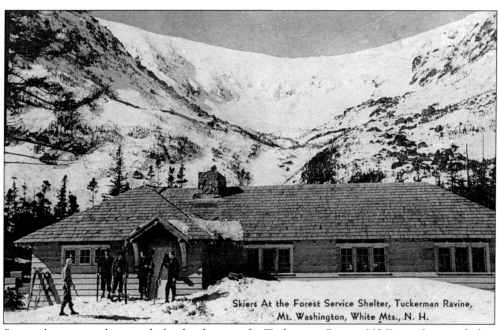

Skiers At the Forest Service Shelter, Tuckerman Ravine, Mt. Washington, White Mts., N. H.

Spring skiers are making ready for the slopes at the Tuckerman Ravine US Forest Service shelter on Mount Washington in the 1938 season. Tuckerman Ravine is certainly the skier's paradise for late winter and spring skiing. Snow may be found in it 10 months of the year.

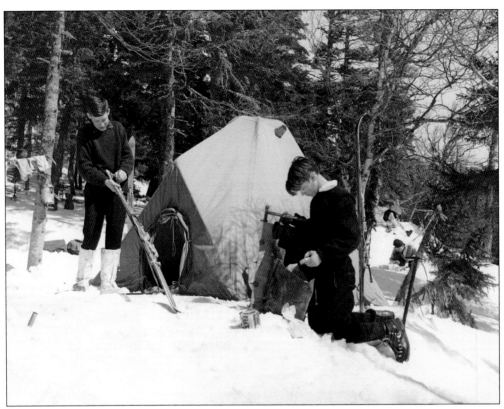

On April 22, 1962, these young skiers are setting up camp at Tuckerman Ravine for the Easter weekend. The two skiers are Richard McLauren (left) and Larry Winshot, both from Lincoln, Massachusetts.

In March 1935, these honeymooners are seen studying the sign on the Pinkham Notch Trail. Paths that were rarely trodden when snow covered them have become ski trails.

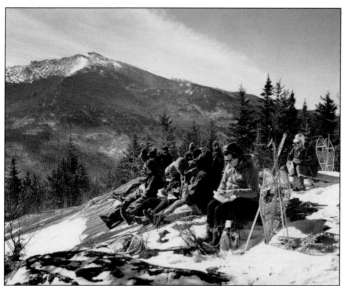

Visiting snowshoe hikers in the White Mountains pause for a light lunch while trekking through the forest. Mount Madison is seen from Pine Mountain (elevation 2,405 feet). The first snowshoe club in New Hampshire was formed by a group of six enthusiasts in Concord during the winter of 1887.

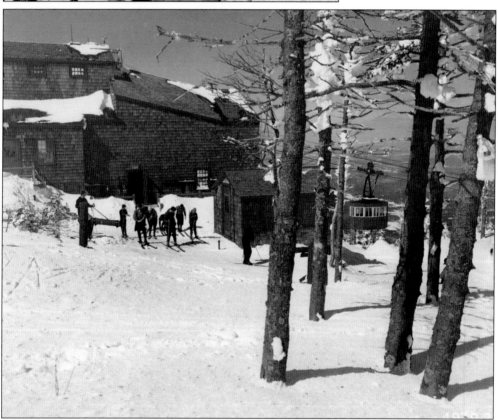

At Cannon Mountain stands the Summit House and tramway car at the Franconia State Reservation. Cannon Mountain ski area is located at the north end of the Cannon-Kinsman Range and is readily available to welcome visitors to this popular summer and winter attraction in Franconia Notch. This dome-shaped mountain was famous for its magnificent profile, the Old Man of the Mountain. This photograph was taken in March 1960.

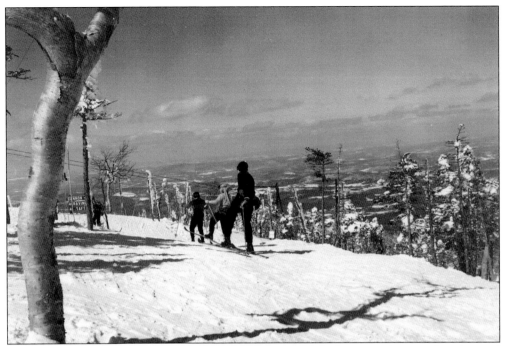

Skiing at the summit of Cannon Mountain (elevation 4,100 feet) is a popular sport for advanced skiers. The mountain's 2,000-foot vertical drop and the well-designed slopes are a major attraction to the area. Aerial tramways have been installed, like those at Cannon, the Balsams' Wilderness, Wildcat (elevation 4,422 feet), and Loon Mountain (elevation 3,065 feet), just to name a few.

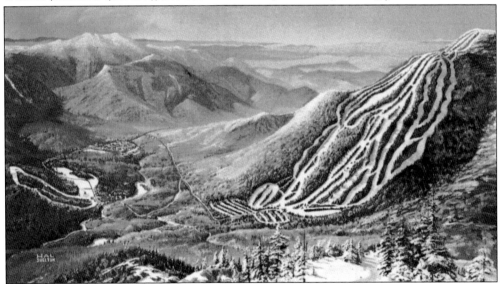

This is a rendering of the Waterville Valley ski area showing the slopes and residential areas on Mount Tecumseh (elevation 4,003 feet). Both the downhill and cross-country ski areas located in the White Mountain National Forest operate in partnership with the USDA Forest Service. Mount Tecumseh, named for the Shawnee leader, is the highest, northernmost summit of the ridge that forms the west wall of the Waterville Valley, beneath which the Mad River flows. This drawing was created by Hal Shelton.

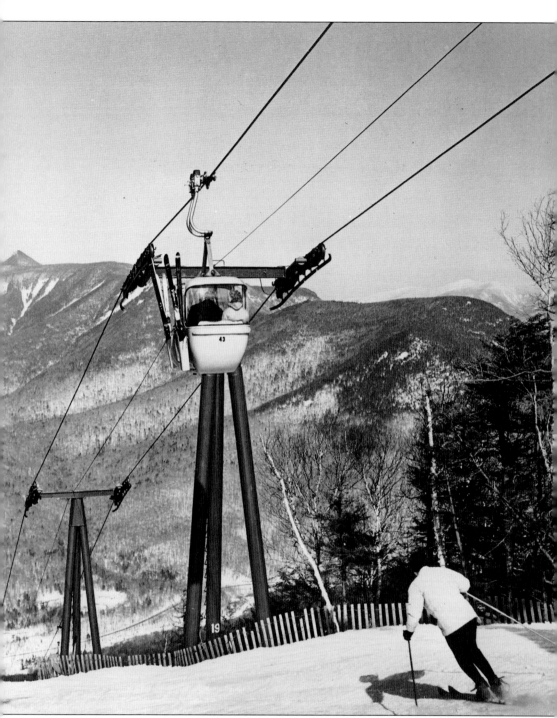

In 1966, Loon Mountain in Lincoln was one of the East's newest and most popular ski areas. The topside view, via this 7,200-foot gondola line, is one of the finest in the Pemigewasset Valley. Many ski resorts in the White Mountains have installed ski tows to the summit for the advanced and beginners. During the 1960s, the area was owned and operated by former New Hampshire governor Sherman Adams.

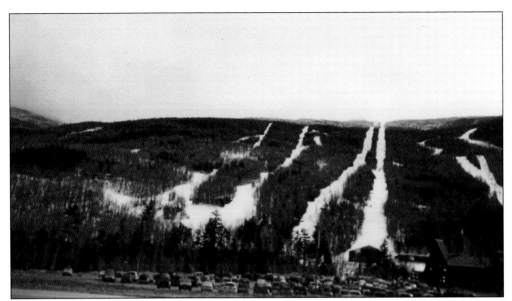

The Wildcat ski area in Pinkham Notch offers a natural blend of mountainous grandeur and winter skiing. Wildcat Mountain offers the most continuous vertical of any ski area in the White Mountains and is closest to the backcountry skiing in Tuckerman Ravine. Wildcat Mountain is located on national forestland and was the first ski area allowed to operate in the White Mountain National Forest on a US Forest Service land-use permit.

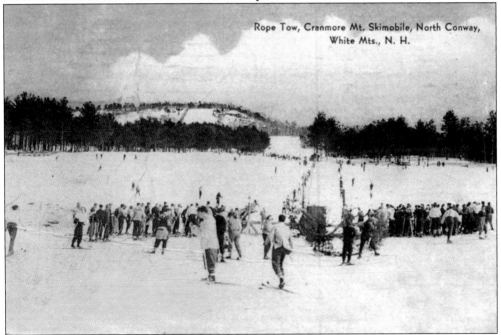

Rope Tow, Cranmore Mt. Skimobile, North Conway, White Mts., N. H.

The Mount Cranmore ski area, located in North Conway, was a popular destination for the snow trains from the 1930s to the 1950s and remains a popular ski resort today. Ascending to the summit of Cranmore Mountain (elevation 1,690 feet), a magnificent panorama of the White Mountains is seen. Mount Cranmore ski area is operated year-round for sightseers in summer and skiers during winter.

Snowshoeing is very popular on the trails near the basin in Franconia Notch. During the winter season, sportsmen now come by the thousands to revel in winter activities. To promote winter sports, the state's national forest officials have built new trails, and there are now hundreds of marked trails to be enjoyed in more than 70 different locations in the state.

This scene looks east toward the Carter-Moriah Range from Little Headwall, Tuckerman Ravine. In the range, the major peaks are Wildcat Mountain (elevation 4,422 feet), Carter Dome (elevation 4,832 feet), Mount Hight (elevation 4,675 feet), South Carter Mountain (elevation 4,430 feet), Middle Carter Mountain (elevation 4,610 feet), Mount Moriah (elevation 4,049 feet), and Shelburne-Moriah Mountain (elevation 3,735 feet). Skiers are seen resting in the foreground.

Discover Thousands of Local History Books Featuring Millions of Vintage Images

Arcadia Publishing, the leading local history publisher in the United States, is committed to making history accessible and meaningful through publishing books that celebrate and preserve the heritage of America's people and places.

Find more books like this at
www.arcadiapublishing.com

Search for your hometown history, your old stomping grounds, and even your favorite sports team.

Consistent with our mission to preserve history on a local level, this book was printed in South Carolina on American-made paper and manufactured entirely in the United States. Products carrying the accredited Forest Stewardship Council (FSC) label are printed on 100 percent FSC-certified paper.

MADE IN THE USA